Making
Our Mark

Making Our Mark

LABOUR ARTS AND HERITAGE IN ONTARIO

*Karl Beveridge
and Jude Johnston*

between the lines

Between the Lines gratefully acknowledges financial assistance for our publishing activities from the Ontario Arts Council, The Canada Council for the Arts, and the Government of Canada through the Book Publishing Industry Development Program.

THE CANADA COUNCIL | LE CONSEIL DES ARTS
FOR THE ARTS | DU CANADA
SINCE 1957 | DEPUIS 1957

Canadä

Canadian Cataloguing in Publication Data

Beveridge, Karl

Making our mark : labour arts and heritage in Ontario

Includes index.

ISBN 1-896357-27-X

1. Trade-unions and art—Ontario. 2. Community art projects—Ontario. 3. Artists and community—Ontario. 4. Labor in art. I. Johnston, Jude. II. Title.

NX180.T7B48 1999 700'.86'2309713 C99-930362-7

Editor: Julie Beddoes
Design and Page Layout: Heidy Lawrance Associates
Printed in Canada by Transcontinental Printing

1 2 3 4 5 6 7 8 9 10 TP 06 05 04 03 02 01 00 99

Between the Lines
720 Bathurst Street, # 404
Toronto, Ontario, M5S 2R4
Canada
(416) 535-9914
btlbooks@web.net
www.btlbooks.com

About the Authors

Jude Johnston is an arts and social justice worker in Toronto. A former Mayworks Festival Coordinator (1994-96) and Work Place Arts Officer (1995-98), she was also a member of the Artists' Action Coalition and the Metro Days of Action Coordinating Committee (1996). She is currently a Counselor with the AIDS and Sexual Health Hotline and the Coordinator of the Access to Health Cards for the Homeless Project. Her art work appears in the book *Stolen Glances*.

Karl Beveridge is a member of the OFL Arts and Labour Subcommittee and was a founding member of the Ontario Workers' Arts and Heritage Centre. With Carole Condé, he has completed many photographic and banner projects with various trade unions and authored *First Contract*, published by Between the Lines in 1976.

This book was written by Karl Beveridge and Jude Johnston except where noted. The sections credited to Jonathan Forbes were excerpted from material that first appeared in *Artists in the Workplace: The Pilot Phase. A Report from the Ontario Arts Council, February 12, 1990.*

Photographs not credited were, in most cases, supplied by the artist. In other cases, every effort has been made to locate and credit the photographer.

Contents

Preface

The course for union stewards had gone well and we wound it up with a performance of union songs led by George Hewison and his band, Rank'n File. One of the class participants, a technician in an oil refinery, came to me with tears in his eyes at the end of the show. "Don't get me wrong, D'Arcy," he said. "The discussions and role plays and everything were great. But the last hour was worth more than the whole rest of the course put together." He pulled two twenties from his pocket when the hat was passed, recognizing that those participants who only had strike pay couldn't contribute much. And he sat with the musicians, the phone operators, the courier drivers, the journalists and the electricians, to celebrate the spirit of the movement that had brought us together.

> Hearts starve as well as bodies,
> Give us bread, but give us roses.

When workers develop collective strength, many outsiders assume that the driving force is wages—bread. Yet through the past two decades, the living standards of Canadian workers have been driven down by the corporate neo-liberal tide sweeping across the globe. To the degree that the labour movement has survived and thrived, it has been on issues of equity, dignity, fairness, the broader social vision—the roses. Without that vision, it is harder to imagine an alternative to the mean-spirited climate around us.

"Bread and Roses," the song of the women textile workers in Massachusetts in 1912, flows from another era when the spirit of justice thrived despite a climate of cutbacks. Canadians today walk on bridges other workers have built; we use public health and education services other workers have fought for and we draw on the images and songs other workers, including cultural workers, have created for us.

This book celebrates construction work in the terrain of the imagination, work that builds conceptual frameworks that others may mock and doubt and finishes surfaces with loving precision while still unsure who will appreciate the sweat and the craft involved.

This creative building has been led by union-positive artists and arts-positive unionists. Both groups have been minorities within their own communities, but the synergy has generated dozens of projects in which professional artists have worked with union locals to produce new visual and performance arts of all sorts. Their stamina and brilliance shows in every page of this book. This coalition has showcased the work in North America's largest and most long-lived labour arts festival, Mayworks. And it has established in Hamilton a place to preserve and celebrate the creative spirit of workers, the Ontario Workers Arts and Heritage Centre (OWAHC). At the Ontario Federation of Labour (OFL), policies and awards and events that pay tribute to labour arts are now a regular part of union business and built into every convention. We haven't turned around the dominant culture but we have carried out some remarkably successful raids to defend the dignity and creativity of workers and their organizations. As a labour educator in four unions (USWA, CWC, CEP and SEIU), I have been privileged to participate in some of these daring and playful initiatives.

All this progress has been in the teeth of rising corporate power. The image of working people and their organizations is smeared daily in the mass media; the social service safety net is being shredded before our eyes. Right-wing politicians dominate the public platforms with their gospel of individualism and their smashing of collective capacity. But the labour movement and its allies in the arts community have sustained the spirit of resistance. We know that caring is of value, that anger is loaded with information and energy, that entitlements have to be defended and extended in each generation. In this, we draw inspiration from other places, especially Latin America, where unionists and their allies in the arts have been

tortured and killed for defending the values that are woven through this book. The music of Silvio Rodriguez and Mercedes Sosa, the weavings of Chilean mothers and Guatemalan children, rise above the pain and fatigue of social struggle. They remind us of the human capacity to dream whatever the setbacks. The labour arts work in this book shows that through sustained and careful and creative effort, we have brought some of our visions to fruition. This book asserts the right to dream and documents the accomplishment of keeping workers and their organizations visible and vibrant in difficult times.

Let us savour the boldness and vision recorded here, and renew our efforts to move cultural work into the centre of labour's agenda; that agenda is to move working people into the centre of the society they have built.

D'Arcy Martin,
*Education Coordinator, Service Employees
International Union, Canada*

Introduction

It is often said that history belongs to those who record it. Labour arts are a record, often of the burning issues and politics of their time. The objects, however, may crumble, disintegrate or fade; their historic significance is then lost to following generations.

Precious remnants, such as photographs, drawings or textiles, point to a long history of labour arts in Ontario, beginning in the 1800s. During the last twenty-five years there has been an outpouring of new work but there is still the danger that this will not survive the twists of time. *Making our Mark: Labour Arts and Heritage in Ontario* records many of these recent works and documents their celebratory and political messages of hope and solidarity.

Making our Mark chronicles labour arts activities produced by the working women and men, community activists and professional artists of Ontario over the last twenty-five years. In every part of the province, songs, videos, writing and visual arts have described the complex worlds of work, labour, class relations and community life. *Making our Mark* demonstrates that creativity is a powerful force that can provide individuals and groups with a voice and a social identity. *Making our Mark* records these voices and corrects the simplistic and stereotypical images of workers and community members presented by mainstream and corporate media, images that often undermine and devalue alternate points of view.

Making our Mark is the final project of the Work Place Arts Office (WPA). In 1995, the Ontario Federation of Labour (OFL) received a grant from the Ontario Ministry of Culture, Tourism and Recreation under the New Democratic Party (NDP), in office from 1990 to 1995. The grant allowed the OFL to hire a trade union arts officer to facilitate the increasing interest and activity in labour arts, and to establish a labour arts office. The result was the opening of the Work Place Arts office. Jude Johnston and Karl Beveridge were hired

How can we ensure that labour history does not become lost? Both informal and formal histories have a role to play. Progress is being made. We need to develop access and information. Working-class people need to keep records to provide historians with the right information, the actual voices, the flow, the human face. We need to hear stories in our own voice.

Carmen Henry,
CUPE and Board member, OWAHC

Frederick Taylor, *Talking Union*, oil on canvas, 1950. The painting depicts merchant seamen meeting with an organizer from the Canadian Seamen's Union (CSU).

to develop labour arts and heritage projects in Ontario.[1] The WPA operated until 1998 and participated in the development of many labour arts projects, bringing together unionists and full-time artists. It was governed by a labour and community-based board of directors.

It was recognized that many labour arts projects were seen only by the communities in which they were produced. *Making Our Mark* documents and celebrates these cultural achievements and brings them to a wider audience.

Many of the works are the result of collaborations between professional artists and union members. Sometimes the artist constructed a work based on interviews and consultations with union members; sometimes the artist and the workers completed the project together. Both methods involved an exchange of information and skills. Through this collaboration, workers found that their daily work involved more creativity than they had realised and artists found support in their quest for fair compensation and recognition for their work.

These collaborations were supported by various arts and union programs such as the Artist in the Workplace program of the Ontario

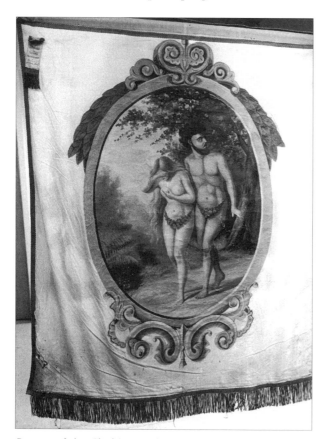

Banner of the Clothiers and Tailors Union, St. John, N.B.
(Courtesy: New Brunswick Museum, St. John)

Arts Council (OAC), the Mayworks Festival of Working People and the Arts and the Banner Competition of the OFL. The Ontario Workers' Arts and Heritage Centre (OWAHC) has supported many exhibits and events since it opened in 1996. Some were solely supported by the union or local involved in the project.

All the World's a Unionized Stage: a History of Labour Arts

Raymond Williams once remarked that the greatest cultural achievement of the working class is the creation of the trade union movement.[2] The struggle for "a fair day's pay for a fair day's work" is also a struggle to create a voice for working people. That voice is a culture that has developed over the past one hundred and fifty years.

Culture is at the root of our identity. It is the recognition, through words, sounds, gestures and marks, of who we are, where we come from and where we are going. It expresses the "spirit" of our lives and our struggles. It is the spirit of our collectivity.

Behind the work in this book is a culture that stretches back to the beginnings of the labour movement in Canada in the 1840s when it was mostly informal and oral. Over time, the work has become increasingly formal and recorded—the art of today's trade union movement.

Emblems of Pride and Dignity: the Art of the Early Trade Union Movement

Until the 1980s there was no formal structure for cultural activities within the trade union movement in Canada but a rudimentary formal culture, or art, has been part of the labour movement since the founding of the first trade unions. Many of the early craft unions carried elaborate banners in their parades and demonstrations. Many of the songs we sing today were written at the beginning of this century. *Solidarity Forever* was penned in 1915 by Ralph Chaplin, a "Wobbly" (member of the International Workers of the World or IWW). *Bread*

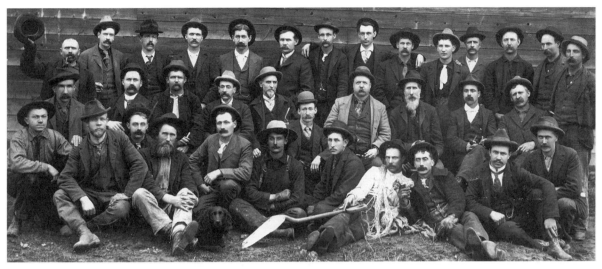

A group portrait of workers circa 1880s (Photographer unknown)

and Roses originated in the textile workers' strike in Lawrence, Massachusetts, in 1912. The origins of these songs point to the strong U.S. influence on Canadian labour history, influence which was cultural as much as it was political. It accounts for the decline of trade union banner making, based on a British trade union tradition, by the time of the First World War.

Banners and union insignia were derived from the pageantry of fraternal societies such as the British Orangemen and Masons to which many early skilled tradesmen belonged. The banners were valued as emblems of identity in marches by craftsmen proud of their work. One of the few to survive from the nineteenth century is a Clothiers and Tailors Union banner from St. John, New Brunswick. Like others of the period, it was made by a commercial banner company. It includes a painted scene of Adam and Eve holding leaves to cover their lower anatomy as well as indicating their evident need for clothes, an image that was common on tailors' banners in England and Australia. The ornate Victorian design symbolized the craft and skill of the union members as did the techniques used in the making of ribbons, buttons and other memorabilia.

Many early union songs added new words to popular melodies. In contemporary terms, they "appropriated" the commercial music of their time, a tradition continued today in songs

of political satire such as those in *Songs of Solidarity, Songs of Celebration* published in 1997 by the OFL Arts and Labour Subcommittee.

Photographs provide, after written accounts, the largest cultural record of early trade unions and working life. Though mostly taken by professional photographers working for the union, the employer or the press, they record working-class life from the 1880s to the present. They include portraits of union leaders, shots of protests and marches, working-class and immigrant community life and workplaces. Early group portraits of workers are interesting for the way that the workers take control of the image. Their casual and exaggerated poses, which can also be seen in photographs of sports teams, defy the conventions of Victorian photography and assert their independence, in spirit at least, from their employer. In some cases, they suggest the actual degree of autonomy and authority many skilled workers held on the shop floor.

The Art of Protest: the 1930s and 1940s.

Full-time artists began to be involved with trade unions in Canada in the 1930s. Politicized by the Depression and often sympathetic to the Communist Party (CP) and associated groups such as the Workers Theatre, many worked through a network of party and union members.

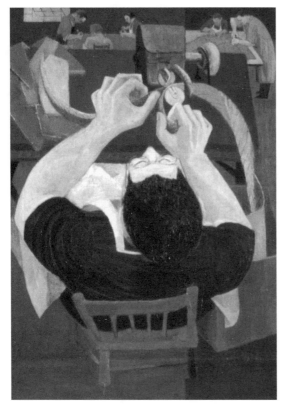

Henry Orenstein, *Self-portrait as Fur Worker*, oil on canvas, 1949

While some of the participants in the Toronto-based Theatre of Action, for example, were union members and some of its productions were aimed at union audiences, there were no formal links between the artists and the union movement. While an artists' union was organized in 1936 and some trade unions purchased or commissioned works of art, there were no arts committees, policies or sustained programs of arts activities in the labour movement. The arts in this period were a parallel activity, sympathetic to the aims of the union movement. In the surge of union organizing around the Congress of Industrial Organizations (CIO) in the late 1930s, unions often enlisted the aid of artists. This spirit continued into the post-war era and lasted until the late 1950s. It subsided, as did much progressive activity, in the grip of the Cold War.

Internationally, too, many great artists were members of, or sympathetic to, communist parties including the Spanish painter Pablo Picasso, the Mexican muralist Diego Rivera, the African-American opera singer Paul Robeson (who once sang on the Peace Bridge at Niagara Falls because he was refused entry into Canada) and the German playwright Bertolt Brecht (who wrote *The Threepenny Opera*). Many modern art movements spoke against the evils of capitalist society and its degradation of life but during the Depression politicized art became more generally acceptable. In this climate it was not unusual for artists to adopt working-class themes. Edsel Ford invited Diego Rivera to Detroit to execute a famous mural depicting workers and many artists were hired by the Works Progress Administration (WPA) to create art works on social themes. The WPA and the American Regionalists were a major influence on Canadian artists.

During this period, many artists in Canada created work with social and political themes, much of it depicting working or unemployed life. Some of them organized the Progressive Arts Club which first met in Toronto in 1932. Soon clubs formed in Montreal, Vancouver, Winnipeg and Halifax as well as in many smaller cities. Out of these came theatre, writers' and visual artists' groups. Wayne and Schuster and musician Lou Applebaum worked with The Theatre of Action in Toronto. The poet Dorothy Livesay edited the magazine *New Frontiers*, a forum for left-wing writers and activists; Leonard Hutchinson created woodcuts of working life in and around Hamilton; Frederick Taylor depicted workers in his paintings of war production in the 1940s.

It is hard to judge the degree of union involvement and participation in these activities. The CP probably linked workers and union organizers with these artists and the artists themselves were often active in supporting union causes. *New Frontiers*, for example, featured articles on various union struggles. In 1938, after a long work stoppage, the short-lived Artists' Union, working for commercial artists and illustrators in Ontario, succeeded in ending the price-cutting common in Toronto commercial studios.

The Labour Arts Guild, housed in the

Boilermakers' Hall in Vancouver, sponsored a series of juried exhibitions titled *British Columbia at Work* at the Vancouver Art Gallery in the 1930s and early 1940s and organized art, music, theatre and dance programs in the community aimed at trade union members.

Frederick Taylor was one of the first painters to exhibit in a union hall in Canada. The exhibition was held at the International Association of Machinists (IAM) Local 712 hall in Montreal in 1944. It included his paintings of war production at the Angus Shops of the CPR. A series of postcards of his drawings was made but the paintings were raffled off to the workers, not kept by the Local.

The United Mine Workers in Cape Breton commissioned Montreal artist Avrom Yanofsky to depict their strike in 1947. During the 1940s, too, the Canadian Congress of Labour hired the designer and illustrator Harry Kelman, who won many awards for his work on the magazine *Canadian Labour*.

The period also produced some books with working-class themes. The best-known perhaps is Gabrielle Roy's 1945 novel *Bonheur d'occasion* (literally "secondhand love" but titled in English *The Tin Flute*). Set in Montreal, it portrays a working-class family moving out of the Depression into the turmoil of the Second World War. *This Time a Better Earth* (1939) by Ted Allen, is a novel about Canadian working-class volunteers in the Spanish Civil War. Allen also wrote *The Scalpel, the Sword* (1952) with Sydney Gordon, on the life of Doctor Norman Bethune. *Waste Heritage* (1939) by Irene Baird sets its story during the occupation of Vancouver Post Office and the marches of the unemployed in 1938. *Eight Men Speak* (Progressive Arts Club, 1933), a play about an attempt to assassinate Tim Buck, was reprinted with other plays from workers' theatre in 1976. Much of the fiction (like Donald Durkin's *The Magpie*, 1923) that raises working-class and union issues is, however, written from the point of view of a middle-class observer rather than seeing events through the workers' eyes.

Music was a seldom-documented part of labour activities in this period. What is documented, however, gives some idea of the extent of musical activity in unions. During the famous 1946 strike against Stelco in Hamilton, for example, local musicians, some of whom were union members, played on the picket lines and held small dances for the strikers. A high point was when Pete Seeger came up from the U.S. to perform in a concert alongside local musicians. The Canadian group The Travelers rose to prominence in the folk revival of the late 1950s.

The steel strike also enlisted the talents of Murray Thompson, a Westinghouse worker and artist who had helped organize Local 104 of the Artists' Union mentioned earlier. Floats, props and picket signs are another unrecorded labour art. A few examples are preserved such as photographs of Murray Thomson's caricatures of political and corporate figures and various floats for Labour Day parades.

Some banners were made during this period. Banners from the International Ladies Garment Workers Union (ILGWU), the Amalgamated Clothing and Textile Workers Union (ACTWU) and the Labor Council of Toronto have survived to this day. They are not as

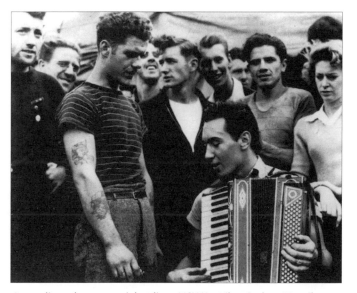

Accordian player on picket line, USWA strike, Stelco, Hamilton, 1946 (The William Ready Division of Archives and Research Collections McMaster University Library, Hamilton, Canada)

elaborate as the Victorian British-influenced banners but display a similar attention to craft in the detailing of letters and logos. No longer seen are the paintings of work-related activities.

A Special Case: Mine Mill in the 1950s.

The first sustained effort at formally linking labour and the arts took place in the International Union of Mine, Mill and Smelter Workers (Mine Mill) Local 598 in Sudbury in the 1950s. With 14,000 members, 598 was one of the largest locals in Canada. Although the nickel mines in Sudbury were not organized until the 1940s, Mine Mill had a presence in Northern Ontario since 1906. Mine Mill developed from the Western Federation of Miners who were, originally, part of the IWW. The IWW, more than any other trade union organization, understood the

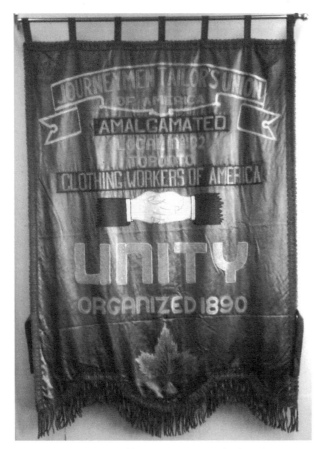

Banner, circa 1920–30's, Journeymen Tailor's Union, ACWU, Local 132, Toronto

importance of the arts in forming identity and solidarity. The earliest theatre and music in North American labour can be traced back to them. The songwriter and organizer Joe Hill was a Wobbly.

Weir Reid was hired as the recreational director for Mine Mill in 1952. He helped organize a dance and ballet school for the local and directed several plays acted by union members. Their performance of an Arthur Miller play won the Quonta Drama Festival Director's award in 1958. Reid organized film screenings, including a showing of the controversial film *The Salt of the Earth*, about striking Mexican-American workers, made by black-listed Hollywood writers and actors. There were concerts by performers such as The Travelers and Pete Seeger. In 1956, Paul Robeson performed at the Mine Mill Hall. Reid was also central to the development of the Mine Mill summer camp that included cultural as well as recreational activities. The Cold War eventually intervened and Reid was dismissed in the midst of the Steelworkers' drive to take over the Mine Mill Local in the early 1960s.[3]

Henry Orenstein, a member of the Fur and Leather Workers, was commissioned by Mine Mill to paint a mural of working class life in Sudbury in 1951. This is now being restored by the Canadian Auto Workers (CAW). Orenstein also painted a mural for his own union.

Art Goes the Way of the Cold War: the 1960s and 1970s

By the 1960s, most of the labour arts activities initiated in the 1930s subsided when the Cold War led to growing marginalization of the CP, with which many of the artists had been associated. The youth movement of the 1960s seemed to leave labour out, concentrating on anti-colonial, anti-war and feminist issues. While these concerns later became integral to labour politics, there is little continuity between the activities of the 1930s, the immediate post-war period and work being done today. There are, however, a few exceptions.

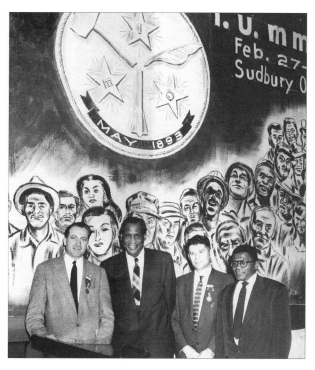

Mike Solski (left), Paul Robeson, Nels Thibault and Lawrence Brown at the eighth annual Canadian convention of Mine Mill after Robeson's performance on February 29, 1956 (Archives of Ontario, Solski Collection)

- In 1969, Mary Shane of the Steelworkers organized the Labour Council of Metropolitan Toronto's first annual art exhibition. It included visual art created by union members from across the city. The Steelworkers in the U.S. also organized a series of annual member exhibitions.

- The folk revival of the 1960s popularized many labour songs. While folk music was, as a popular form, largely eclipsed by the rise of commercial rock in the mid sixties, it still has a following and exerts an influence in popular music today.

- The late 1960s saw the development of a new Canadian nationalism which had a particular impact on the arts, particularly around issues of Canadian content in all the cultural industries. Many progressive artists, while rejecting the CP, supported independent Canadian unions through the Canadian Confederation of Unions (CCU). A high point of this relationship was artists' support for the Artistic Woodwork strike in Toronto in 1973.

- Toronto Workshop Productions, under the direction of the late George Luscombe, produced a number of plays on political and working class themes including *The Working Man*, written by Len Peterson and sponsored by The Labour Council of Metropolitan Toronto in 1972. Founded in 1963, TWP's greatest success came in 1974 with the production of *Ten Lost Years*, based on Barry Broadfoot's book about life in the Great Depression.

Other developments during the 1960s are also worth noting. In 1957 the Canada Council for the Arts was founded. It was followed by the Ontario Arts Council (OAC) in 1963 and other provincial arts councils. (The Saskatchewan Arts Board was established in 1948.)

SECOND LABOUR COUNCIL'S ART EXHIBITION

The Education Committee's Art Exhibition attracted more than one hundred high quality paintings and sculptures from members of local unions in the Metropolitan Toronto area.

Mrs. Mary Shane, the Art Director of the Steelworkers did an excellent job in preparing the Exhibition.

The Show was opened by Henry Weisbach, the Committee's Secretary. Tom Murray a retired Steelworker Representative from Pittsburgh, Pa., U.S.A., and an artist in his own right congratulated the Labour Council for sponsoring the show. Mayor William Dennison of Toronto expressed best wishes for the Exhibition and stated that trade unionists have shown what excellent use they make of their leisure time.

36

Second Labour Council's Art Exhibition, *Labour Council of Metro Toronto Yearbook '70*

This public funding of the arts arrived with the post-war package of social programs. As with many such government programs, funding was closely tied to the private market and tended to reflect middle-class tastes in most of what it supported. However, as public agencies, arts councils had to allow a certain amount of democratic access to their funding thus supporting some socially-engaged art. More recently, arts councils have begun to acknowledge and support community arts programming and the OAC has supported labour arts initiatives since the mid-1980s.

Another development worth noting is the rise of artists' unions and associations. A number of organizations were formed in the 1960s and 1970s representing most of the artistic disciplines. The organizations with members in the cultural industries like film and TV are, generally speaking, affiliated with the broader labour movement, while those with a predominantly fine-arts membership are still struggling over their status as unions.[4]

The Arts Become Part of Labour: Ontario in the 1970s and 1980s

In the late 1970s, a new generation of artists was becoming active in conventional politics and in the politics of culture. Some came from a traditional understanding of art as social commentary; others, aware of developments in Latin America, became active in popular theatre and participatory art movements. Some were influenced by the women's, gay and lesbian, environmental, peace and development politics. At the same time, a flood of cultural theory was being written, particularly in Britain and France, which viewed cultural activity itself as an arena of political struggle. New organizations brought these artists and activists together to provide the structure on which a new labour arts network was built.

The Development Education Centre (DEC) was formed in 1971 under the auspices of OXFAM. In 1972 it became an independent educational resource centre. By 1974, it had become a film and book distribution outlet

and soon moved into publishing and media production. In 1975, DEC organized a conference and festival on art and politics under the title "pARTisan." Partisan Gallery opened soon after as a progressive artists' gallery and separated from DEC. Partisan began a long relationship with the Labour Council of Metro Toronto, creating its Labour Day floats and props. In 1977, the CBC produced the film *Maria*, written by Rick Salutin and directed by Alan King. The film portrays the life of a woman immigrant garment worker in Toronto. In 1980, Rosemary Donegan, who had worked at DEC, produced a series of posters for the Canadian Labour Congress (CLC) of historic Canadian paintings that celebrated work and community life. The posters were a huge success and became a reference point for later labour arts activities.

Also in 1980, a broad coalition of progressive artists formed the Cultural Workers Alliance (CWA). Founded in Montreal by a group associated with playwright David Fennario, it grew to include Quebec and Ontario-based artists. In Ontario, it provided a sense of common identity for artists of various political persuasions and disciplines. It published an issue of the magazine *Spleen* and remained active until 1982.

At the same time, a new generation of activists was coming of age in the labour movement. There was a growing link between cultural activity and union education and communications. Traditionally, artists were asked to perform at rallies and produce banners and props for demonstrations for little or no money, in effect as donations to the cause. Increasingly, as a result of the new arts activism, artists were paid as workers to conduct songwriting and theatre workshops as part of union educationals. They were also commissioned by unions to produce posters, videos and films for campaigns on a wide variety of social issues.

A pivotal event in Ontario set the stage for today's labour art activities: a symposium organized by the Swedish Embassy with the CLC and the OAC in November, 1982. A delegation

from Sweden, which included the Minister of Culture Bengt Göransson, was invited to give a presentation on community arts in Sweden at the Art Gallery of Ontario (AGO). The symposium brought together, many for the first time, a large number of artists and union activists. It was also the first time that a public arts funding agency indicated an interest in unions. The Swedes described how their government delegated funding decisions for arts and cultural programming to three community sectors: unions, the church and temperance societies. These ideas were discussed further in workshops but it was at a meeting called by Jim MacDonald of the CLC that things got rolling. The first labour arts committee, the Labour Arts and Media Working Group (LAMWG) was set up in a nearby bar after the conference was over. An important precedent set at this impromptu meeting was that a labour arts committee would include an equal number of union and artist representatives. Those present at the meeting were integral to the development of later initiatives such as Mayworks, the Artist in the Workplace program and the Ontario Workers' Arts and Heritage Centre (OWAHC).

One of the LAMWG committee's first jobs was to document the various labour arts activities taking place across Canada and abroad as a resource list for artists and unions. This research was assisted by the Canadian Conference for the Arts and published as *The Links: Trade Unions and the Arts Community in Canada*. It culminated in the Working Partners Symposium held in 1983 at the Steelworkers' Hall in Toronto. The day-long meeting, organized by LAMWG, featured presentations by artists and unionists who had worked together as well as a series of workshops on how labour arts should be developed. Amazingly, most of the recommendations that came out of the symposium were eventually carried out, although some took ten years or more. These included the development of a cultural policy for labour, putting union representatives on the boards of cultural institutions, developing joint funding programs with arts funding agencies and

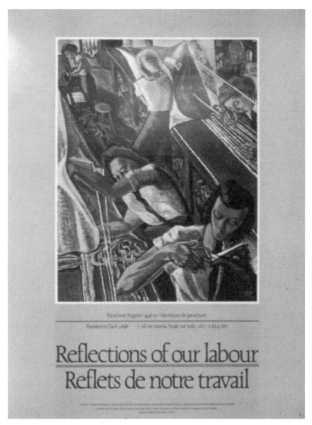

Paraskeva Clark, *Parachute Riggers*, 1946–47; from a set of six posters, *Reflections of Our Labour*; produced by the CLC, curated by Rosemary Donegan.

encouraging input from labour into cultural policy on such issues as representation and access.

But more importantly, the symposium solidified a sense of common purpose. It identified a movement for both the artists and unionists. It was followed by a large exhibition of labour arts at the OFL Convention later that year, with works by artists from across Ontario including poetry readings and theatre performances. Importantly, the exhibition was funded by the OAC, the first time an arts agency in Canada had funded a labour arts event.

In 1985, LAMWG was transferred from the CLC to the Labour Council of Metro Toronto for practical reasons. Most of its members were from Toronto and the Labour Council was able to provide immediate support, especially for the projected Mayworks Festival. The group continued, however, to work with a broad network of artists and union affiliates.

A major event that demonstrated the link between labour and the arts was the Eaton's Boycott May Extravaganza held at Massey Hall on May 6th, 1985. Initiated by the Labour Council of Metro Toronto, the OFL Women's Committee and the Retail, Wholesale and Department Store Union (RWDSU), it was organized by a coalition of artists and union activists in support of the Eaton's strikers. Performers included Margaret Atwood, Jackie Burroughs, The Parachute Club, Eric Peterson, Sneezy Waters and Nancy White. The benefit helped set the climate for the introduction of Mayworks a year later.

A number of international labour arts projects also served as examples for the development of activities in Ontario. The most comprehensive is the Art and Working Life program in Australia, established in 1981 under the Community Arts Development Unit of the Australia Council as a response, in part, to a cultural and recreation policy adopted by the Australian Congress of Trade Unions (ACTU) in 1980. Artists and unions could apply to the program together to undertake projects in various disciplines. The revival of Australian trade union banners, which inspired the establishment of the OFL trade union banner competition, was supported by this program. At its height in the mid-1980s, projects worth three million dollars a year were funded under the program. It survives today but with much reduced funding due to right-wing attacks on the program, the Australia Council and the arts in general.

More international models include:

- The Bread and Roses program of the New York Hospital workers, Local 1199, one of the few cultural initiatives to survive the Cold War. It helps artists and union members to produce and exhibit their work.
- The work of the Brazilian Augusto Boal has had a huge influence on popular theatre work in Canada.
- The United Farmworkers (UFW) included cultural work in their organizing drives and had an influence on many Canadian

unionists who worked with them in the 1970s.

Another international model was Mayfest in Glasgow. Mayfest was a huge multidisciplinary festival organized in part by Alex Clarke, Arts Officer of the Scottish Trade Union Congress and an activist member of Actors' Equity. Catherine Macleod and D'Arcy Martin, both of whom were union staff reps and involved with LAMWG, visited the festival in 1985. When they returned, members of LAMWG met with the OAC to discuss support for a labour arts festival in Toronto. The director of the OAC was then Walter Pitman, a former NDP member of the Ontario Provincial Parliament and sympathetic to the request. The first festival, coordinated by Catherine Macleod and Sue Ditta, took place in May of 1986 with funding from the OAC and various union affiliates.

Mayworks made it apparent that public funding was needed to both encourage and support artists to create work with unions. New material for presentation at a festival, for example, could not be produced without support. It was equally important that union members be able to work directly with artists on union ground rather than in art space. In 1987, LAMWG made a proposal to the OAC based on the Australian Art and Working Life program. Eventually, a pilot program for labour arts projects was put in place.[5] The program was designed so that artists and unions applied jointly for grants, the union contributing twenty-five percent of the project costs, the OAC seventy-five. In 1988 the first Artist in the Workplace grants were awarded. Jonathan Forbes, one of the founders of DEC, was hired to facilitate and report on the pilot program. Its success can be measured both by the quality of the work produced and the number of communities reached across the province. It has also become a model for other community arts programs in Canada. Many of the projects completed under the Artist in the Workplace program are included in this book.

A sign that the arts were now a part of the life of the labour movement was the purchase

of art works for the CAW Family Education Centre in Port Elgin. The CAW purchased a hundred thousand dollars' worth of original Canadian art that is now on display at the centre as well as 240 reproductions which hang in all the rooms.

Consolidating the Gains: the 1990s

With the advent of the Artist in the Workplace program, in 1988 the OFL established, under its Education Committee, an Arts and Labour Subcommittee made up of full-time artists as well as representatives from the major unions in the province. The establishment of the Subcommittee signaled labour's formal commitment to the arts.[6]

In 1990, Kathie Muir, then Trades Union Arts Officer for the United Trades and Labour Council of South Australia, visited Canada bringing images and examples of Australian labour art. Canadian unionists were excited by colourful and sophisticated hand-sewn fabric banners. At the next meeting of the Subcommittee, the OFL launched its banner competition. The first banners were displayed at the OFL convention in 1991. Three prizes are now awarded at each convention for the most innovative approach, the best design and the banner with the greatest involvement by union members in its making.

The OFL has also instituted a Cultural Award, presented at its biennial convention, given to an artist or trade union member who has made an outstanding contribution to the development of labour arts. It has developed two cultural policy papers, sponsored symposiums on cultural issues, secured appointments of labour representatives on the boards of arts institutions and lobbied the provincial government on cultural issues.[7]

Although not as exciting as programs that see the creation of art works, policy formation is an extremely important component in the development of labour arts. Policy gives the various cultural initiatives and activities formal recognition within the labour movement. Policy also indicates the degree of accep-

tance of an activity and ensures, to some degree, its survival within the movement. The policies passed in the 1990s would not have seen the light of day at a labour convention in the 1970s. The OFL has adopted two policy papers on the arts. The first, *Towards a Living Culture*, was adopted at the 1993 OFL Convention. It outlines the role that labour can play in the development of both professional and community arts and recognizes cultural activity as an essential part of union and community life. The second, *Cultural Work*, was passed in 1997 and covers the economic and working conditions of professional artists and the role labour can play in organizing and representing their concerns. A third policy is currently being developed on cultural industries and the arts.[8]

The 1990s also saw Mayworks Festivals spring up in communities across Canada though not all take place every year. Vancouver, Winnipeg, Ottawa and Edmonton now have annual festivals. The *Festival de Arte y Trabajo*, was organized in Buenos Aires in 1995 with talk of another in 1999.

For many, a crowning moment of the past twenty-five years was the opening of the Ontario Workers' Arts and Heritage Centre (OWAHC) in 1996. In a sense, the Centre becomes the physical home of all that has been achieved in labour arts. It combines labour's history with its cultural and artistic achievements.

Missing from this brief history is the spirit of the collective process that went into its making; a history of the many people who sat around kitchen tables planning and around boardroom tables negotiating; of professional artists who realized that creativity is not their exclusive domain and of workers who saw that art should be an expression of their lives and experiences.

This book builds upon the efforts of those who have encouraged and supported labour arts in the past. These people deserve thanks. They include the many, too numerous to name, who worked on the early labour arts committees, Mayworks, the Artist in the Workplace

program, OWAHC, and served on the Board of Directors of the Work Place Arts Office. It is recognized that this book cannot cover all the various activities that have taken place and there are many that have been missed or might not have been known to the authors.

We would also like to thank the artists who have contributed their writing and time as well as Between the Lines publishers for assisting in the preparation of this book.

Making our Mark is a testament to the creative spirit and energy of the workforce in Ontario, which includes professional artists. It is our hope that the book will inspire others to recognize the power of creative expression and to initiate labour arts projects in their own workplaces and communities.

Notes

1. In 1998, program criteria were changed to include a variety of community arts projects. While this has resulted in a welcome increase in community arts funding, the focus on labour art has been reduced. It is now called the Artist in the Community and the Workplace program.
2. Raymond Williams, *Culture and Society: 1780–950* (London: Harper and Row, 1958), p. 327.
3. The Sudbury Mine Mill local was split in 1962. The United Steelworkers of America (USWA) won representation of workers at INCO, Local 6500. Mine Mill Local 598 continued at the Falconbridge Mine and merged with the CAW in 1994, the last surviving local of Mine Mill.
4. Artists' union/associations include the Association of Canadian Television and Radio Artists (ACTRA), Canadian Actors' Equity Association, the Writers' Union of Canada, Canadian Artists' Representation (CARFAC—for visual artists), the Playwrights' Union of Canada, the League of Canadian Poets and the American Federation of Musicians.

Cultural industries unions include Communications, Energy and Paperworkers Union (CEP—newspapers and television), International Association of Theatrical and Stage Employees (IATSE), Directors' Guild of Canada, Canadian Union of Public Employees (CUPE), Broadcast Council (CBC) and Ontario Public Service Employees Union (OPSEU—museum gallery and art college employees).

5. The proposal was prepared by Rosemary Donegan and Karl Beveridge and negotiated by D'Arcy Martin. It received support within the OAC from Chris Wootten, the Director, Naomi Lightbourne, the Community Arts Officer, and from the Executive Assistant Ron Evans who had been an organizer of the Swedish symposium in 1982. The main point of contention between the OAC and LAMWG was the question of whether corporations would be eligible for funding under the program. LAMWG successfully argued that unions are membership-run and would, therefore, have a better chance of delivering the program. It was also pointed out that corporations did not truly represent individual workers.
6. LAMWG then became the Labour Arts and Media Committee of the Labour Council of Metro Toronto and York Region and dealt with municipal art issues. It is now largely dormant.
7. The first symposium, in 1995, brought representatives from the U.S. (Moe Forner from the New York Bread and Roses project), Scotland and Argentina. It focused on community arts and the labour movement. The second, in 1997, focused on the second OFL policy paper and issues concerning the working artist.

Labour representatives were appointed to the boards of the OAC, the AGO, The Royal Ontario Museum (ROM) and the Young Peoples' Theatre (YPT). Under the Mike Harris government, labour reps remain only on ROM and YPT boards.
8. The first arts policy passed by a union in North America was *Going Public: The Steelworkers Communications Policy*, written by D'Arcy Martin and adopted in 1985.

The OWAHC, Banner Making and the Mayworks Festival

A lot of people believe artwork needs
to be brought back to the people.
A lot of union members need to be
given a little more confidence to
recognize the talent they do have.

Linda Mackenzie-Nicholas,
President, Northumberland
and District Labour
Council

Outdoor sign based on OWAHC logo, designed by Karl Beveridge (Courtesy OWAHC)

Our Place

The Ontario Workers' Arts and Heritage Centre

by Mary Breen and Craig Heron

October 17th, 1998 was a happy night at the Ontario Workers' Arts and Heritage Centre (OWAHC). Two hundred people had arrived for the opening of a new exhibition on auto workers in Ontario. The artist-designer, the historian-curator and the local Canadian Auto Workers (CAW) officers were all smiles. But so too were several retirees from Hamilton's former Studebaker plant who had dug up their photos and memorabilia and poured out their memories to help in the production of the exhibit. Their story was finally being told.

Ten years earlier, when a small group of unionists, artists, teachers, historians and community activists first started meeting to plan the Centre, the kind of collaboration that would produce such a wonderful exhibition was

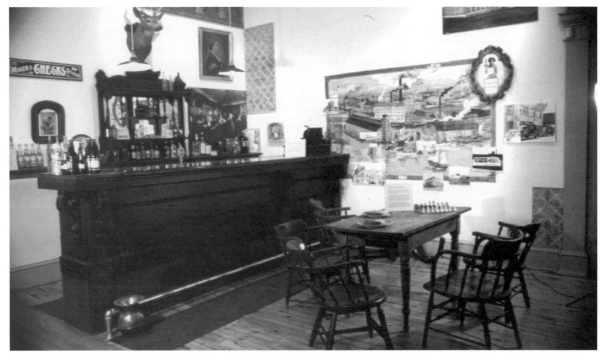

Booze: Work Pleasure and Controversy exhibit, 1998 (Courtesy OWAHC)

Third Sector Recycling from *Making Time*, an exhibition by Jim Miller, 1997 (Photo James Williams)

only a distant dream. We had no money and certainly no building but we knew that we wanted to pull together all the exciting new work in labour art, labour history and labour-studies programs into a high-profile centre. This centre would have a province-wide mandate and be a place where the history and culture of working people could be gathered in, preserved, celebrated and shared. We were concerned that too many cultural and educational institutions were ignoring workers' arts and heritage and that too many of the memories and records of the workers' past were fast disappearing.

Turning that dream into a reality was a

Spinning Yarns, a community arts project and exhibition, 1997 (Photo Yvonne Maracle)

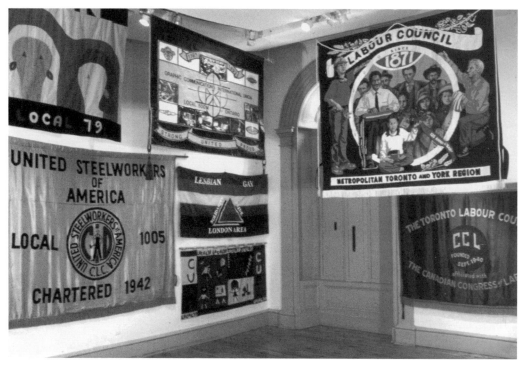

As We Go Marching, Marching: Canadian Workers On Parade, an exhibition of banners, photos and labour memorabilia, 1997–98 (Courtesy OWAHC)

slow process. The OFL came on board at the start and appointed three representatives to our Board. Labour's moral and financial support has been crucial ever since. To raise awareness of the project, we made a short video called *All We Worked For* and held a large conference on working heritage in Toronto in 1993. By the Spring of 1994, we had an optimistic feasibility study. We eventually convinced the Ontario government and the City of Hamilton to help us buy a building and get our programs up and running. The final step was to get a heritage building in Hamilton renovated and open to the public by November, 1996.

With its long history of labour activism and a sympathetic city council, Hamilton was an ideal location. The beautiful old Custom House, built in 1860, has been transformed into a busy site of varied programming. Our exhibitions have covered many themes in workers' history and labour art: on-the-job working conditions, major strikes, protests and labour festivals, immigrant and Third World experiences. Also addressed was workers' time off the job, from making ends meet, to playing on the harbour, to boozin'. We have also held walking tours, concerts, plays, (especially the phenom-

enally popular one-person play about Italian heritage in Canada, *Cu Fu*), film screenings, and celebratory banquets. We have helped unions across the province write their own histories.

More and more, OWAHC is building on momentum in different communities or around certain issues by hosting or co-sponsoring meetings, conferences, festivals and special events by union and community groups from all over the province. As Canada's only labour museum, OWAHC needs to be a lot of things to a lot of people without a lot of resources. Luckily, the energy in the place makes the air crackle. Visitors feel it when they walk in. It causes them to hang around. Brother Tom Veitch from Peterborough described it beautifully: "*Our* place for *our* artistic endeavours, *our* history and *our* culture."

Mary Breen is the executive Director of the OWAHC.

Craig Heron is a labour historian and teaches at York University. He is a member of the OWAHC Board of Directors.

Union Banners: Strength in Solidarity

Who can forget the sea of colourful and inspiring union banners floating above the thousands of people marching at the Metro Days of Action in Toronto in 1996?

For centuries, communities have used banners to establish a public identity, send a message, celebrate their unique qualities or serve as a rallying point. Churches, peace groups, lodges and unions are only some of the organizations that use printed, painted or stitched textiles in this way. Photography is a recent and welcome addition to the tools used in banner making.

Unions, in particular, have a long history of banner making. Union members carry banners in Labour Day parades, marches and rallies. These textile emblems tell the stories of work and union histories. When not in use, the banners hang in union halls and offices to inspire and inform members and visitors.

Union banners, at the turn of the twentieth century, usually showed images of work, of the machines or tools used in a particular trade or something that symbolized the union. They were elaborately painted by professional graphic artists, usually men. These early banners were modelled on British trade union banners of the period. More than ten thousand banners were made in Britain between 1830 and 1930. Some of these have survived and are still carried in demonstrations today. Stunning images of male workers, often in heroic stances, appeared on many banners, indicating the strength and nobility of the worker. The central theme of these banners, however, was strength through union solidarity.

Banner making continued in Britain and Australia but almost died out in Canada after the First World War. Banners after that usually included only a union name and logo. Some presented a union's political message but they were, for the most part, hand-painted spur-of-the-moment efforts.

As we noted in our introductory chapter, banner-making by unions in Canada has recently revived in response to Australian banners brought to Ontario in 1990 by Kathie Muir. Soon after, a banner competition was established by the OFL. Some of the new banners were co-funded through the OAC Artist in the Workplace program. Many, however, were funded solely by the union involved. Since

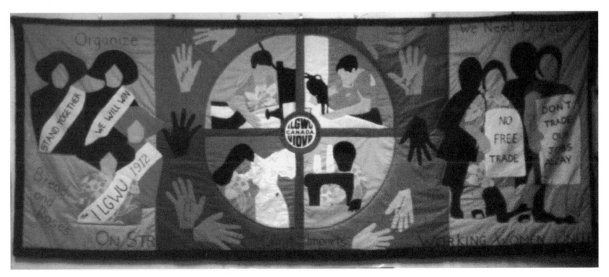

ILGWU banner, fabric appliqué, Phillipa Hajdu, 1989

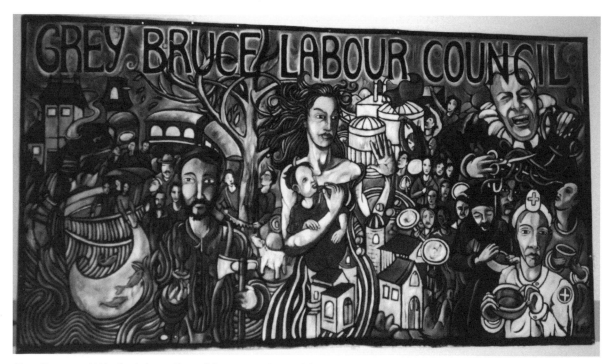

Grey Bruce and District Labour Council banner, paint on fabric, Michael Last and Gayle Fairchild, 1996. The banner highlights the past, present and future of labour in the district, stressing the problems of cutbacks in industry

Kathie's visit, over twenty union banners have been produced in Ontario.

The Australian banners were inspiring because of collaborations between union members and professional artists. In this process of cross-pollination, artists and workers learn about each others' work. In addition, unionists are given new forms and techniques to express their identities as union members. Banners are an opportunity for union members to consider the images of themselves and their work they would like to project. They are also an opportunity for members to consider what their work means to themselves and their communities. In some cases, members themselves help to create the banner.

There is now a rich collection of union banners in Ontario and several banner projects are described below.

Artist: Winsom

Union: Hotel Employees Restaurant Workers Local 75 (HERE 75)

At the 1997 OFL Convention, three entries dis-

played in the Banner Competition were submitted by HERE Local 75. The banner created with Winsom (see colour section) won a first place award. Eight members of HERE 75 met for a number of weeks with Winsom, a visual and textile artist, to design and make a quilt about their work and life experiences. Each of the rank and file members made at least one square for the colourful and vibrant quilt showing their experiences as bartender, server, housekeeper, laundry worker, hotel locksmith and cook. The quilt has since become a fixture at HERE 75 rallies and meetings and has inspired other banner making projects in the Local.

Artists: Lynda Lapeer, Dorothy Caldwell

Union: Communications, Energy and Paperworkers Local 534 (CEP 534)

Lynda Lapeer painted and Dorothy Caldwell batiked and stitched images based on discussions with the women of CEP Local 534. Lynda and Dorothy discovered that the women shared a deep respect and love for their first President, Gloria Stonnard. On one side of the banner,

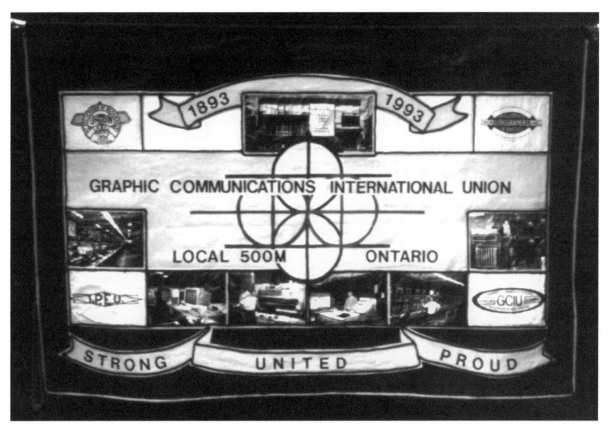

Graphic Communications International Union Local 500-M, banner, paint on fabric, Michele White, 1993–94

Lynda and Dorothy surrounded a central image of Gloria with four historical and contemporary CEP logos. Within the design are the words, "It all started here," in other words, with Gloria. Also shown on the banner (see colour section) are images of women at work, in the home, in the plant and on the picket line.

Artist: Laurie Swim

Union: Kingston and District Labour Council and The International Brotherhood of Electrical Workers (IBEW)

Over a period of several months in 1995, Kingston workers met to design and make a textile mural with Laurie Swim (who also made a banner for the IBEW) to commemorate the labourers who built the Rideau Canal between 1826 and 1832. They chopped fabric into thousands of square pieces then stitched them together into a pointillist image. The mural shows canal workers pulling together on a meandering red stream or thread in the shape of the canal. It symbolizes and celebrates both their life energy and the actual lives lost in the building of the canal; it is also a lasting testament to the present-day workers who came together to produce an exceptional work of art (see colour section). Its title is *Pulling Together*.

Artist: Judith Tinkle

Union: CUPE Local 79

In 1992, Judith Tinkle was asked by CUPE 79 to become involved in a quilt project to commemorate the Local's fiftieth Anniversary. Judith considered her role to be "rather similar to that of a conductor: the music was to be made by CUPE 79 members while I was there to make sure that everyone was playing together."

The project evolved into three large quilt works. Eighty-five squares were made by union members using various media: photographic transfers, painting, appliqué, embroidery and

knitting. These are surrounded by a band on which the signatures of hundreds of union members are printed. As Judith says, "once the quilts were finished, everyone felt immensely proud and satisfied."

In 1995, Judith was involved in another CUPE 79 union member project. This time they produced five very different banners, referring to a variety of issues such as health and safety, multiculturalism and child care. The banners (see colour section) are in frequent use for marches, parades and demonstrations.

Artists: David Camacho and Daniel Gallegos from Mexico (*Ojos de Lucha*); Joseph Sagutch, Lynn Hutchinson, Shawn Grey, Marco Figueroa, Liliana de Irisarri from Toronto (the Toronah Support Group)

Curators: Scott Marsden and Nazeer Khan

Union: CEP

Mexican artists, Canadian artists and members of CEP collaborated on a large, colourful mural-like banner to show the drastic impact of NAFTA on workers and community members in Canada, the U.S. and Mexico. Sponsored by CEP, the painted banner is described in their *Journal* as a "powerful display of cross-cultural solidarity." A face is portrayed from several viewpoints as a reference to the people from the three countries. There is a multi-purpose hat which could be worn by a peasant, a farmer or a CEP worker. Environmental concerns are shown by rivers which turn into "arteries that sustain life." There are many other images in this incredible montage, including the teal-coloured CEP union triangle. A swirl of vivid colour surrounds the main figure as a reference to the strength and energy of working people. The finished banner (see colour section) was exhibited at A Space Gallery in Toronto in 1994 and at numerous CEP events. It is a strong symbol as well as an example of international solidarity and creativity.

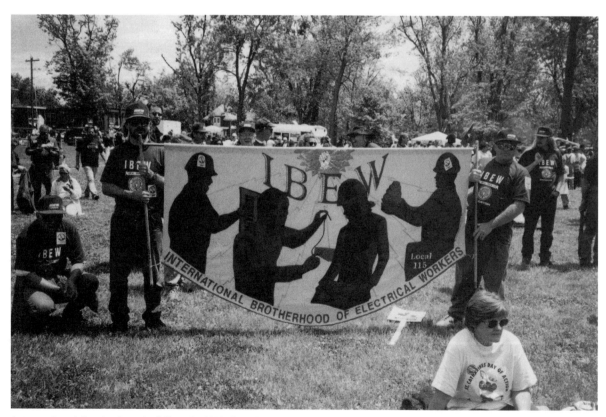

International Brotherhood of Electrical Workers (IBEW) Local 115 banner, fabric appliqué, Laurie Swim, 1995

Mayworks Festival of Working People and the Arts

by Catherine Macleod

From the whimsical and insightful lunch buckets that workers and artists decorated to the T-shirts, the caps, the murals, the monuments, the union button collections, the postcards, the song books, the CDs, the concerts, the videos, the dramas and the storytelling—the Mayworks Festival of Working People and the Arts has showcased the work of hundreds of union members and professional artists in union halls and in community spaces. For over a decade it has carried the personal stamp of Festival coordinators who worked closely with the voluntary board and programming committees. Each coordinator—Catherine Macleod and Sue Ditta in 1986 and then Pat Wilson, Rhonda Payne, Louise Garfield, Pat Jeffreys, Jude Johnston, Lillian Allen and Min Sook Lee—introduced new concepts and new artists to the labour arts family.

The Festival has put down solid roots in Toronto, Vancouver, Winnipeg and Ottawa and also appeared in various forms in Cobourg, Ontario (under the direction of then Northumberland Labour Council President Linda Mackenzie Nicholas), in Moncton, New Brunswick and in Windsor (through the work of the CAW poet Ron Dickson). Now festivals are starting in Edmonton and in Buenos Aires, Argentina.

The challenge for Mayworks from the start was to apply the principals of cultural democracy to an arts festival to allow greater access and broaden its social base. The Festival was determined to expand the traditional geographic or regional definition of community to include all groups of people who had things in common, especially members of the labour movement. This definition recognized shared beliefs, aims, language and, of course, class. A democratically based arts festival, the organizers argued, had to recognize issues of gender, race and sexual preference, as well as physical and mental abilities. The usual kind of arts festival promoted mostly Euro-centric classics with an occasional "multicultural" variation and excluded most of the world's cultures and realities. While the wonderful achievements of Euro-centric fine arts were still appreciated, Mayworks organizers placed this work in its historical and social contexts. In this way, Mayworks moved beyond traditional arts education or the touring of

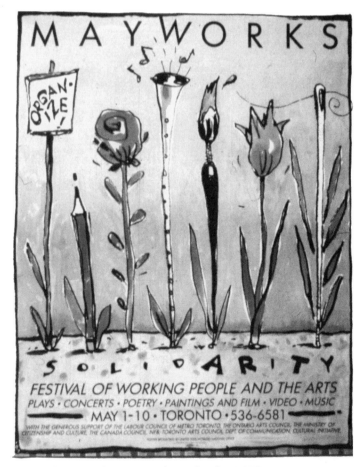

Mayworks Festival poster, Barbara Klunder, 1987

Working People's Picture Show, Company of Sirens, 1986 (Photo Gayle Hurmuses)

boast that it was presenting a better balanced budget than that of any government in the country. Former OFL Secretary-Treasurer Julie Davis, who hosted Womantalk in 1991, credited Mayworks with forging the arts-labour link. By that time the OFL was commissioning music and backing the OAC's Artists and the Workplace Program. "The spark of all of this was Mayworks, five years ago," Davis said.

The decision by Mayworks to make cultural resources available to workers and

professional set-pieces in union halls, to creating and presenting a new, more representational and more inclusive body of work.

By 1990, the Festival organizers knew they were on solid ground. Union and arts council contributions increased and the Festival could

unions—everything from photography, print, stage, film and video facilities and technicians —was working. Womantalk, Working Image and various other community outreach and popular theatre programs were clear evidence that this approach was successful. What follows

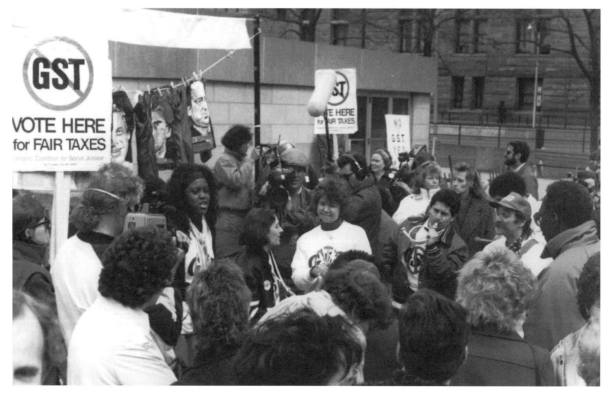

Hitting Home, an agit prop play against the GST by Ground Zero Productions, Mayworks, 1990

is a small sample of some of these Mayworks activities.

Working Image

Working Image, the annual Mayworks juried exhibit of art by union members, encourages working class expression in the visual arts. Although the Festival welcomes full-time artists who want to connect with labour—to show their ideas and skill to workers—the Working Image exhibition is reserved for workers themselves to show art that they create. The Festival provides a curator who sends out a call for entries. With a jury made up of artists and workers, the curator considers the entries and chooses the work to be shown.

Sunday Afternoon, collage, Shlomit Segal, Toronto Typographical Union, from Working Image exhibition, 1990.

The seeds of the Working Image exhibition were planted at the first Mayworks Festival by painter Dana Boettger. Boettger pointed out that, at that time, "apart from hostile media images or social realist stereotypes, depictions of working life in art are almost non-existent. Since most of us go to a job every day and build our lives around what we do for a living, there's a notion that we are one-dimensional creatures who do not dream, do not create and certainly do not make art."

Boettger's exhibition that year was called Artists at Work; it focused on work by artists who either belonged to unions or whose work was inspired by labour or social justice themes. One piece in the show was painted by Eleanor Lewis during a bitter Steelworkers strike at Horton. The painting was used by CAW Local 3598 to raise thousands of dollars in support of their strike.

The first Working Image exhibition, co-sponsored by the CAW, was organized and curated by Carole Condé and installed at A

Space Gallery in 1989. Carole has continued to organize the exhibitions over the years and is still active in Mayworks. The Working Image exhibition presented an alternative—that of establishing a space where the creativity of working class people could be nurtured, critiqued and valued in its own context.

Each Working Image participant is asked to work from his/her own perspective, concerns and intentions. With such open criteria, the resulting work has been informed by the full spectrum of issues that concern working people—beauty, racism, nature, feminism, the environment, family, the workplace, sexuality, the home, spirituality, power and current events.

Music in the Workplace

Since workers spend a lot of their time at work, Mayworks decided to take the music to the workplace. While the Festival's mandate is to move beyond the exclusivity of what is known as the 'fine' arts, appreciation of them was nowhere more evident than with the contri-

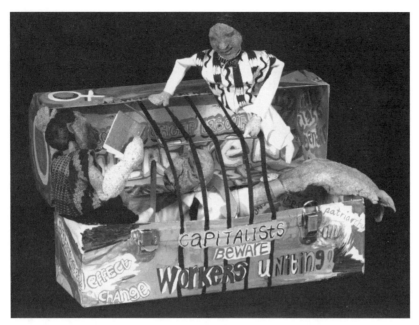

Lunch Box, Grace Channer, commissioned by Mayworks, 1992

Nothing But Class performing at the Caterpillar plant occupation as a part of the Music in the Workplace program

to perform for their members and for the public at the GM van plant, the Metro Reference Library, the Federal Building at Queen's Park and the Hydro Building in Toronto, all of which were to become main venues for future Mayworks programs.

The Music in the Workplace program has celebrated many other forms and types of music. Arlene Mantle, who is well known in the labour community, performed at many different sites. Anden Sur and Nazka have played Latin American music at the Federal Building, sponsored by the Canadian Employment and Immigration Union (CEIU) Local 556 and PSAC. Swing Pigs, with their blend of old jazz standards and blues, and the Incurable Romantics, with their harps and flutes, have played at the Consumers Gas Building and Toronto Reference Library, sponsored by the Energy and Chemical Workers Union (ECWU) Local 001 and CUPE Local 1582. Rappers New Black Nation played at Centennial College and the Ontario Hydro Building, sponsored by OPSEU Local 558 and CUPE 1000. The rappers Nothing But Class played at a demonstration at the closed Caterpillar plant, sponsored by CAW Local 1967.

bution of the Ruth Budd Quintet to Mayworks. CAW Local 303, Canadian Union of Public Employees (CUPE) library workers, the Public Service Alliance of Canada (PSAC), OPSEU Local 593 and CUPE Local 1000 invited Budd

The Evolution of Womantalk

Mayworks' first literary excursion presented readings by six Canadian authors over two evenings at the Rivoli Cafe in 1986. The event

was coordinated by novelist and OPSEU member Brian Flack. Each of the readers Flack invited was either from a working class background or had, during their writing careers, focused on workers and their environments. They included playwrights Carol Bolt and Rick Salutin and poet Dionne Brand.

In the second year, the literature program was called Speaking Out and followed the model established by Flack. It introduced Vancouver's Helen Potrebenko, a novelist and short story writer. Her most recent book, *Sometimes They Sang*, had just been published by Press Gang.

In a move that would distinguish the literary programming of Mayworks from then on, David Fennario, Canada's most renowned working class playwright, read from his play *Joe Beef*. But he didn't read alone. He invited union members, including Communications Workers of Canada member and labour arts activist Lynn Margeson, to read with him. In passing the spotlight to workers, Fennario signaled a major shift in the literary programming to one that would actively encourage and invite working people to read from their own work.

By 1989, the literary program shifted its focus again and changed its name to Womantalk. Hosted by CLC Vice-president Nancy Riche and coordinated by Ann Marie Wierzbicki, it became an annual platform for the voices of women. The first Womantalk included readers Libby Scheier, Maja Bannerman and Afua Cooper, all members of the League of Canadian Poets, as well as Mary Rowles, OPSEU, Martha McLaughlin, OPEIU, Darlene Christie, CAW and Susan Meurer, a former Amalgamated Transit Union (ATU) member.

In 1997, Coordinator Lillian Allen added a second evening of performances by "young women with attitude" entitled Womantalk Too. In 1998, under Min Sook Lee, it became Live Action Ladies and Queer Talk. Each year Womantalk grows, each year it changes and each year the voices of women are coming in louder and clearer. As with Womantalk, each year the Mayworks Festival grows and changes and the voices of all working people become louder and clearer.

Catherine Macleod is a writer and producer. Her recent book Waking Up in the Men's Room *is published by Between the Lines Press. She lives in Kincardine, Ontario.*

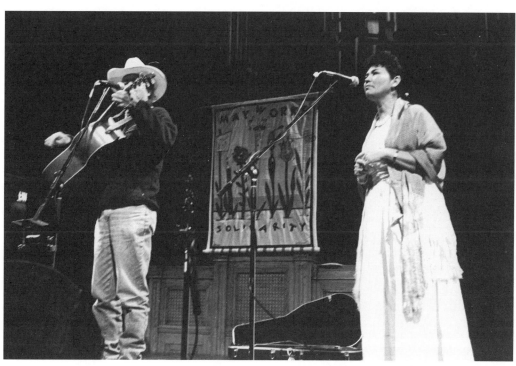

Los Leones de Xichu, a *huapango arribeno* troubadour group from Mexico led by Guillermo Velazquez, performing at Mayworks in 1995 (Photo Vincenzo Pietropaolo)

Music and Drama

The working people of this province have a strong and dynamic culture. Stories and pictures of their lives remind the labour movement of its own history and of the contributions it has made to life in Ontario.

Charlie Stock,
President, Kingston and District Labour Council

Artists in this section:

Len Wallace

Faith Nolan

Arlene Mantle/Sage

George Hewison

Susan Meurer and Allen Booth

Tom Brouillette

Mixed Company and Scott Marsden

Lib Spry

Rhonda Payne

Company of Sirens

SPIT and QUAC

Anne Chislett

David Archibald

Patricia Hennessy Laing

Robert Fortin

Lawrence Welk Was Never Like This

The Music of Len Wallace

Len Wallace is a songwriter and virtuoso musician who "wields the people's instrument—the accordian."* He is also a teacher-educator whose material is the "extraordinary lives and history of working men and women." He believes that artists can play a strong activist role in unions and the community.

Len brings his songs and music to the line whenever he can and has performed at countless demos, rallies and picket lines to "bring together the troops and encourage people." He has also performed with Pete Seeger at New York's Lincoln Centre, for thousands of marchers on Ottawa's Parliament Hill and during the Metro Days of Action in Toronto.

In 1995, Len was commissioned by CBC radio to write his song "Life on the Line" about the changing nature of work in auto plants, telephone companies and retail food outlets. The most recent of his three independent recordings is *Midnight Shift.* The title song is dedicated to the miners who lost their lives at Westray.

Len has compiled two collections of songs, *Labour's Songs in a Booklet* and *The Socialist Tradition in Labour Songs.* He has conducted workshops on labour music at the CAW Educational Centre in Port Elgin, bringing to light the stories and struggles of working people while exploring the role that music can play in celebrating workers' lives. Participants in workshops are encouraged to bring their own stories and songs to share.

Len Wallace shows both a serious touch and a humorous streak in all his material. As songwriter Bob Bossin says, "Lawrence Welk was never like this."

From Life on the Line

"You'll get yourself a job," they say when
 you're in school.
"Just work hard and buy yourself a dream.
 Follow the rules. Life's what you make it.
 That's the way it's always been."
 They say that work is the human
 condition,
 But the dealer's changed the rules of
 the game.
 Now they're shuffling the cards and
 cutting the deck
 —nothing's ever gonna be the same.

From Men of the Midnight Shift

So, who's to profit and who's to blame
for the deaths of 26 men
Except for the ones who won the mine
and smile at the dollar held in their hand
How they smile at that dollar in their
 hand.

<div style="text-align: right">Len Wallace</div>

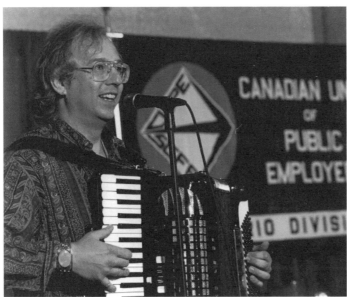

Len Wallace performing at a union event

*Quotations are from biography and publicity material.

Songs for Working People

A choir workshop conducted by Faith Nolan and Multicultural Womyn in Concert with OPSEU

by Jonathan Forbes

Faith Nolan rehearsing for a Mayworks concert, 1995

Locked-out medical lab workers from Hamilton had no idea that they would perform in a concert in the Grand Ballroom of Toronto's Sheraton Hotel, but that is just what they did along with Faith Nolan and other artists from Multicultural Womyn in Concert (MWIC). The occasion was the annual convention of OPSEU and members sang the songs they wrote in two series of workshops with the artists in 1990.

Barb Taylor, MWIC Coordinator, describes one of the workshops:

> Union members faced with racism on the job talked about issues like promotion, equal pay and the need for union support, in a jam session with Faith. A second session was held where Faith was joined by two other Black Nova Scotian artists, Lionel Williams and Delvina Bernard, a founding member of the a cappella group Four the Moment. Union members jammed on the congas, shakereh and other instruments.

The life that Faith lives, like the lives of her parents and their parents, is connected to labour. Her father was a coal miner in Sydney, Nova Scotia, and her mother was an office worker and member of OPSEU. The labour movement has been one of the few places in an otherwise capitalist-run music business where Faith Nolan, an activist, Afro-Nova Scotian, lesbian singer/songwriter, has found a home. It has also given her a chance to perform her original songs about working people.

From Long Time Coming*

It's been a long time coming
be a long time here

No jobs, no schools,
no hope for the future here
It's been a long time coming
be a long time here

From the teacher to the preacher
down to the policeman's gun
they don't believe we're equal
it just keeps on and on

It's been a long time coming
be a long time here

Daddy works in the coal mine
mama had to clean
just enough to survive
never enough to gain

Faith Nolan

Jonathan Forbes is a founding member of DEC. He is currently working as a researcher and consultant.

*From *Faith Nolan Compilation*, 1986–1996

The Voice That Launched a Thousand Struggles

The Music of Arlene Mantle

by Gary Wylie

When the history of union song and music in Canada is written, Arlene Mantle, or Sage, will be mentioned first and foremost. Arlene's music is truly a reflection of her life, of the richness in her soul, her wealth of experience and her struggles as a woman living in poverty.

"The First Lady of Union Song" was born in 1939 in Caledonia, Ontario. Adopted at six months into an abusive household, she later dropped out of high school, married at 19 and mothered five children, becoming a single parent after leaving an abusive marriage. She survived by working as a solo performer or living on social assistance.

> Her welfare cheque feels sticky in her hand.
> She's under the system's wings,
> attached to a hundred strings,
> the music stopped, but she still has songs
> to sing.
> Oh, have you met a woman without
> choice?

When she left the bar scene because of illness, Arlene began writing songs about her life and the lives of other low-income women; she also began to publicly identify as a lesbian. As her work with anti-poverty groups increased, she was surprised to find a large amount of classism in the women's movement.

> Hey, hey, what about class,
> we have to address it,
> we can't let it pass.

Arlene began to make connections between differing struggles. She conducted song-writing workshops with the Gainers' workers in

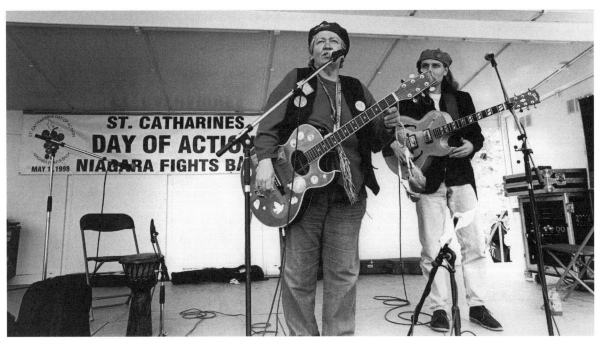

Arlene Mantle performs with Kevin Barrett at the St. Catharine's Day of Action

Edmonton in 1988 and was charged with violating a court injunction at a picket line concert. She often performed for free on picket lines. Twenty years of singing for picket lines, rallies, demos, strike support benefits, has accompanied solidarity work with people in El Salvador, Chile, South Africa and Nicaragua.

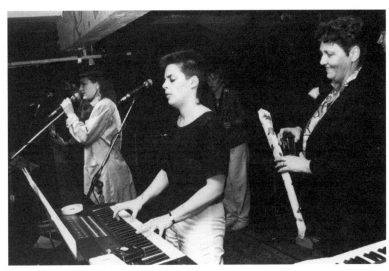
Arlene Mantle with her band at Mayworks

> All around the right is rising.
> People we need organizing.
> Smash the right is our song,
> Cause we know the right is
> wrong.

As well, Arlene recorded an album, seven cassettes and a CD. *In Solidarity* was produced for the CAW and *Ready to Roll* for the USWA. Arlene worked with film-maker Laura Sky on the score for *Moving Mountains* and wrote music for the play *Straight Stitching*, which won a Chalmers Award in 1990.

Arlene has also faciliated more than 300 workshops with diverse social justice groups, from England to Sweden. In 1983 she travelled to Chile with Bruce Cockburn as part of the First Congress of Artists and Cultural Workers. In 1987 she attended a women's conference in Moscow. She has also worked at the Labour Arts Exchange at the George Meany Centre in Washington and been a part of the People's Music Network.

> I'm singing solidarity forever.
> Trying hard to keep my union spirit high,
> but my spirit's almost spent
> and I can't pay the rent.
> Have you ever seen a union member cry?

Arlene assisted members of Violence Overcome in Creative Ensemble (VOICE), an organization for battered women, to create music for a performance and worked extensively with battered and troubled youth and children. Her songs "Fires of Transformation" and "Children's Voice" were used in films which won awards at the Chicago Film Festival. Her song "Listen to the Children" is currently being made into a music video with Lorraine Segato and others.

> Children have so much to teach us.
> If we're open, they can reach us.
> Touch a place within our soul.
> From a time when we were whole.
> Listen to the Children.

In the 1990s, Arlene began her own healing journey, working through issues of incest and physical abuse as a child. Through this journey, it became clear to her that activism and spirituality walk hand-in-hand. Her latest CD, *Full Circle,* is by a woman with a rekindled spirit.

Arlene/Sage strongly believes that music is an integral part of the struggle for justice. The voices and works of artists, cultural workers and ordinary people are part of the struggle for a better world.

> Breaking through the barriers,
> turning things around,
> doing it together,
> finding Common Ground.

Gary Wylie is a trade unionist and community activist.

Labour Troubador and Organizer

The Music of George Hewison

Born in 1944 in Mission City, British Columbia, George Hewison grew up with the songs and music of his family of fishers. George continued the family traditions; he wrote and performed songs as he rose to the position of Secretary-Treasurer in the United Fish and Allied Workers Union (UFAW).

For Hewison, a strong musical tradition is the hallmark of a strong union. He says, "You

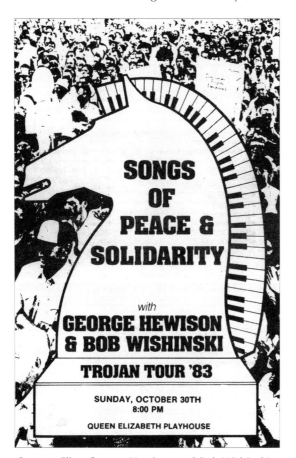

Concert Flier, George Hewison and Bob Wishinski, 1983

can always tell a fighting, militant organization from one that has gone to sleep by the attitude to music." One of his favourite sayings is "Beware of the organization that sings, for it is invincible."

George's teenage performances were followed by extensive radio, television, and concert hall work. He composed many original music pieces, including the award-winning score for John Kelly's 1969 theatre production *Fantasy, Flight and Feathers*, performed in British Columbia as part of the Dominion Drama Festival. George toured Canada and performed internationally at festivals in Sokolov and Berlin along with such notables as Pete Seeger, Billy Bragg, and Amandla.

George is an energetic organizer of labour music classes and workshops for union members and members of the public. He conducted a successful pilot program on labour music for the CAW. When he announced the first week-long labour music seminar in 1992, over 200 people from across Canada applied for twenty-four places. Workshop members included a Newfoundland fisher, an Ontario airline worker and a B.C. rail worker. They shared a fierce pride in their work and a deep love of music.

They studied the legacy of labour music and created new songs. More seminars followed and hundreds of workers have been recruited to carry labour music forward. One result has been the formation of the Labour Music Network.

George and other members of the CAW from across Canada formed the Rank'n File Band in 1992. They have produced a CD/ cassette *Fighting for a Working Future* and have performed at rallies, conventions and concerts. Many of the lead vocals are by George Hewison and Paula Fletcher. The CD, comments a reviewer, "highlights a broad spectrum of themes, from the impact of layoffs and cutbacks in unemployment insurance, to the problems of racism and violence against women."

George describes the attraction labour music has for workers this way:

A segment of the music of working people reflects their collective struggle to survive, i.e. to organize against all odds in an unequal and unjust society. We call this music labour music. We know that a song is more than lyrics, rhythm, and pleasant melodies. It is fundamentally an appeal to emotion … but labour music is more. It is our untold labour history, our sense of solidarity and community, and our collective vision for a better future—of hope, justice and equality for all."

George laments that our cultural institutions like the CBC, the CRTC and the Canada Council have "never been cultural champions of Canada's working class." He emphatically states,

Rank 'n File Band, CD Cover (Photo Ralph Leuthardt)

We need a culture which does not diminish, patronize, fear or depreciate the workers' movement of our country or hide our heritage and the significance of our contribution. We want and need a culture that affirms our dignity and identity as workers, expresses and reinforces our values, and projects our view of a better world to come. In short, we want a culture which empowers us, not for ourselves as a workers' movement, but so that the workers' movement may find its way as a most effective and reliable bulwark for all of our collective Canadian struggles for a better, more just and equitable society.

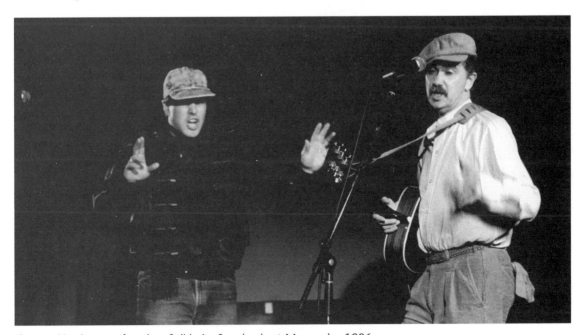

George Hewison performing *Solidarity Songbook*, at Mayworks, 1996

Poster for *The Shadow Boxers*

The Shadow Boxers

A musical play by Susan Meurer and Allen Booth with United Rubberworkers Local 232

by Jonathan Forbes

The play was a success by any measure; it filled the hall for three nights and each time received a standing ovation. This was the result of an unusual artistic collaboration between composer Allen Booth, playwright Susan Meurer and the members of the Rubberworkers Union (URW) Local 232 (now USWA/UR), in Etobicoke, March 1989.

The audience saw a workshop production of *The Shadow Boxers*, a musical play about plant closures. Union members who performed alongside professional actors also contributed ideas for scenes and songs, created the set pieces, contributed costumes and cooked a lot of food for opening night.

Many union members in the audience got so wrapped up in the play that when a scene about a union meeting was performed, they started to shout down the speakers and offer their own opinions as if they were at an actual meeting. They finally had to be called to order for the play to continue.

Although this was Susan Meurer's first play, the scenes about working life deeply touched everyone in the audience. The workshop was directed by Pierre Tetrault and the play has since been performed on CBC radio.

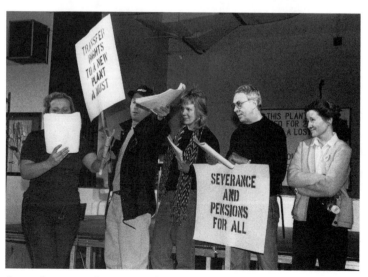

Scene from a performance of *The Shadow Boxers* (Photo David Smiley)

Art Meets Work: Boilermakers in Concert and The Rite of Steam

Danceworks by Dancer and Boilermaker Tom Brouillette and members of the International Brotherhood of Boilermakers Local 128

Tom Brouillette has been a member of the International Brotherhood of Boilermakers since the age of 15, following in the steps of other family members. Most recently employed at Petro-Canada, Tom is also a professional dancer, having danced with the Desrosiers Dance Theatre, Claudia Moore and numerous other independent artists. He has extensive experience as a choreographer and movement teacher for both professional and nonprofessional dancers.

Recognizing that the movements of boilermaking—lifting, hauling, running, climbing and rigging—are themselves a kind of dance, Tom sought to build a bridge between tradespeople and the arts. He began to develop a site-specific piece in collaboration with boilermakers and professional dancers. The result was a 1994 multidisciplinary dance piece *Art Meets Work: Boilermakers in Concert*. This was followed by *The Rite of Steam* in 1997.

As the creator of an earlier movement workshop, Body Wisdom for Everybody, Tom was familiar with the needs of both professional dancers and his co-workers.

Material from a series of music and movement workshops was developed into a structure for the final performance piece.

The project gave boilermakers an opportunity to discover and develop the creative skills that they used everyday on the worksite and also come to grips with some of the tensions that arise on the job through the inclusion of humorous vignettes. Members described the worst/best/most memorable and most terrifying moments on the job. The project answered the question, "What is a Boilermaker" for workers and members of the public alike. Both *Art Meets Work: Boilermakers in Concert* and the *Rite of Steam* celebrate a trade that many of us depend upon but which few of us know very much about.

Art Meets Work was performed against the backdrop of the refineries of Petro-Canada's L.O.R.O. Park in Oakville. Boilermakers constructed the steel set; music was beaten out with wrenches and other industrial tools on forty-five gallon industrial drums and tools.

The Rite of Steam was performed at Joseph Workman Auditorium in Toronto as part of the 1997 Mayworks Festival. The multidisciplinary piece made elaborate use of slides, video and music.

Art Meets Work

The Rite of Steam

While the goal was for boilermakers to dance all the parts of each piece, Tom found

The Rite of Steam

Art Meets Work

that they were most comfortable suggesting content and constructing work-like sets. Professional dancers were hired to develop the final pieces in conjunction with the boilermakers, Laurie-Shawn Borzovoy, videographer, and Mathew Fleming, musician. During rehearsals, an increasing number of Petro-Canada employees spent their off time assisting with the project. The results are two exciting collaborative performance pieces combining the skills of boilermakers, lighting technicians, video artists, carpenters, musicians, dancers, and cooks.

O.P.P.ression— where do I stand? and Stories from the Inside

A play forum on sexism and sexual harassment with Mixed Company and CAW Local 1967; an exhibit of paintings on the same themes by Scott Marsden

O.P.P.ression—where do I stand?

Over several months in 1991, male and female aerospace workers, members of CAW Local 1967, created a short play based on their experiences with sexism and sexual harassment in the office and on the shop floor. They worked with a group called Mixed Company. Their play, *O.P.P.ression —where do I stand?* raised questions like,

"How do sexist attitudes and behaviour affect women?" "Why do men act this way?" and "What can be done to confront these issues and work for change."

Simon Malbogat of Mixed Company, explains that a play forum brings people together to work on common issues, not just talk about them. The play is performed twice; the second time, the audience can stop the action, take the place of a character who is being harassed or discriminated against and try out their own solutions to the problem.

O.P.P.ression—where do I stand was presented at the Local 1967 hall in December, 1991, to a full house of union members. There were many interventions and many ideas and variations were tried out. The play forum brought art and life together, using theatre as a tool for social change.

Stories from the Inside

Scott Marsden's vivid paintings, based on stories of sexual harassment in the workplace by the same aerospace workers, were exhibited at Partisan Gallery during the Mayworks Festival. *Stories from the Inside* was a joint project by Scott and CAW Local 1967.

Painting by Scott Marsden from *Stories from the Inside*

Theatre as A Tool

The Theatre Works of Lib Spry

A Filipino garment worker, in an effort to communicate her own homesickness, sings in Tagalog to a fellow worker from Hong Kong. Her intensity and passion bring tears to the audience's eyes, even those who do not speak her language.

This is just one of the images that Lib Spry carries with her from the twelve years she has been creating shows with labour, which range from the garment workers' play, *Straight Stitching*, to street theatre to her current project, a huge community play with the Ottawa and District Labour Council.

Lib creates community events based on interviews, research, discussion and song-writing workshops, aiming for a balance between the artist(s) and community members. The event is often in the form of forum theatre; the play is performed through once and then repeated, with the audience encour-

aged to intervene and try out their own solutions to the community's problems. This is a tricky but rewarding process. In *Straight Stitching* for example, textile workers were encouraged to create a forum theatre piece about their first strike in fifty years. But the workers were afraid that they might alienate their bosses so instead, the writer Shirley Barrie listened to the vivid stories of the workers and created a play with Lib about women's realities. The final play involved both professionals and some of the garment workers as actors.

Straight Stitching, with music and songs by Arlene Mantle (who met with the women to develop the songs), was performed at Mayworks and later adapted for a smaller professional cast and toured to schools, universities, ESL classes and union events.

Labour groups hire Lib and her company, Passionate Balance, to create or perform plays about specific issues. If a play has not already been written, Lib gathers materials through workshops, interviews and research. The union has final approval of script and production. The Public Service Alliance of Canada (PSAC), for example, commissioned Lib to produce a bilingual forum play about stress in the workplace. The result was *STRESS/ANGST/May I*

Scene from *Straight Stitching*, 1987

help you/ puis-je vous aider? One character is dealing with a sexist boss; another is an older experienced man working in a new department where his expertise is not recognized. He is also struggling with alcoholism.

Other commissioned works include *The Health and Safety Show*, which explores dangers faced by CUPE workers on the job and *It's Our Life, Isn't It?* for CUPE National, a play about the life of a woman in the world of globalization and downsizing. This is still in draft form but has become the basis for a labour community play to be staged in Ottawa in the year 2000.

Lib has performed street theatre only once, at the March 15 rally on Parliament Hill in 1993. Dancing, prancing street clowns representing Kim Campbell and Jean Charest plunked down milk crates and used them as mini-stages to bellow out a series of short routines about NAFTA, GST and the other issues on the Tory agenda.

Lib finds that working with labour "always means exciting work, challenging issues and progressive politics." The downside is that sometimes, "the needs and realities of theatre workers are, ironically, ignored by unions. As well, professional actors sometimes condescend to non-professional union members." For unionists, actors and audience members alike, however, the results are usually well worth the effort.

Lib would like to have a "discussion in this country about what we want to do in labour art, how we want to use it." She believes it can go much further than one-time requests for special events. She "dreams of labour drama camps, where people can learn the basic skills to create shows, characters, and puppets to take into their own communities and get things going there." Lib would also like to write plays about working people for the mainstream and put into the limelight a "large segment of the Canadian population who are rarely seen on our stages … because when labour and theatre cook, it is the most exciting thing in the world."

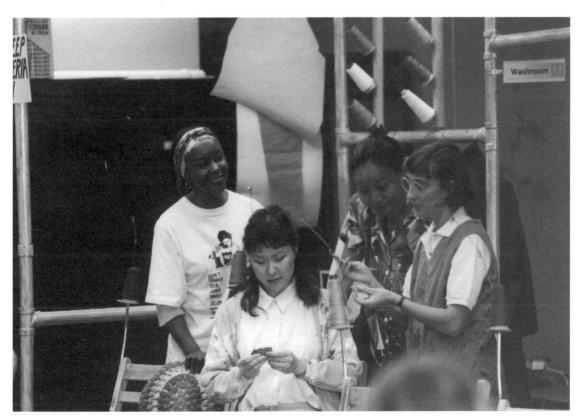

Scene from *Straight Stitching*, 1989

Cornering the Dragon

A pageant produced by Riverbank Productions with the Peterborough & District Labour Council, its affiliates and the Peterborough Social Justice Coalition.

By Rhonda Payne

*C*ornering the Dragon* is a giant puppet street theatre spectacle that was collectively created as a community pageant. It was first performed at the Peterborough Days of Action in June, 1996.

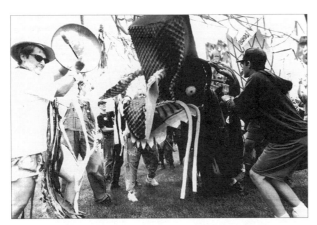

The Deficit Dragon on the streets of Peterborough. From *Cornering the Dragon*, Riverbank Productions, 1996

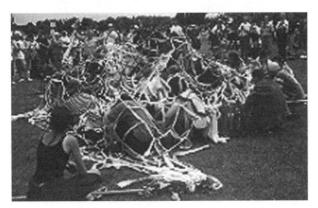

Overthrowing the Deficit Dragon with the Community Net. From *Cornering the Dragon*, Riverbank Productions, 1996

The images for the Pageant emerged from a series of popular theatre workshops I directed and call Power Play. They draw on a variety of improvisational theatre techniques that explore issues of empowerment, personal growth, community building and social change.

We made a giant dragon puppet with a foam head mounted on a ten-foot high backpack and scales with the names of Canadian mega corporations painted on them. There was an escort of Corporate Suit puppets and two-dimensional painted cardboard houses representing services and organizations which had been targeted by budget cuts. The more-than one hundred participants in the pageant came from a variety of sectors: the inter-faith community, unemployed people, artists, students, adult learners and members of affiliates of the local labour council.

We took it to three sites. The first, at a major intersection, had an installation that represented Peterborough's community services, institutions, and work places. The Deficit Dragon, escorted by a group of Corporate Suits and attendant drummers, rampaged through the street scene, scattering the buildings and people.

A circus-like installation at the second site celebrated the "Weaving of a Net of Communal Action." Alternative groups such as co-op housing and LETS (Local Economic Trading System) were portrayed on banners. Participants drummed and sang a song written by an adult learning class.

The third site was in a park. Twenty participants performed under a thirty-foot square Community Net. In the final sequence, the Community Coalition overthrews the Deficit Dragon with the net. A segment of the Pageant was later performed on the street during the Metro Toronto Days of Action, in October, 1996. In October, 1998, the Dragon travelled to Ottawa to once again meet the Tories.

Rhonda Payne, Artistic Director of Riverbank Productions, has been a professional theatre artist for more than twenty years.

The Working People's Picture Show

A play by the Company of Sirens commissioned by Organized Working Women

Organized Working Women, in celebration of their tenth anniversary, hired a small group of theatre performers and writers in the mid 1980s to develop a series of skits about working women. The skits were so well received at the anniversary convention that a theatre company formed around them. The Company of Sirens was born and the skits became a play, *The Working People's Picture Show*. The Company performed the play at over one thousand locations across Ontario from union halls and conventions to community and school groups.

The Working People's Picture Show was a flexible project with content tailored to the concerns of each audience on topics like women in the workplace, family life, daycare, sexual harassment, free trade and the history of women. Company members found that they were constantly learning from their audiences and that these experiences became part of the play. Collectively written, the play combined songs, skits, music and poetry, often dealing with difficult issues in a humorous and uplifting manner. Characters included Professor Chauvinist, Hannah the Housewife, Rosemary Rosedale and Sarah XJ2—the Secretary of the Future.

The company included Diana Braithwaite, the late Lina Chartrand, Shawna Dempsey, Catherine Glen, Cynthia Grant, Amanda Hale, Aida Jordão, Makka Kleist, Diane Sokolowsky, Alison Sealy-Smith and Marilyn Mason.

From Job Song
(performed as a rap with a choral bed-track of "work, work, work, work")

Mable Moriarity did combination work.
She was a nurse, an accountant and a
 scheduling clerk.
She was a cook, a teacher, and a fantastic
 lover.
What exactly was she?

Home-maker and mother.

Maria DaFoseca was a landed immigrant.
She cleaned office buildings to pay the
 high rent.
The boss didn't like it when the workers
 went on strike.
Maria said:

"Hey, Mr. Smith, we deserve a pay hike!"

The Company of Sirens

Aida Jordão and Catherine Glen of the Company of Sirens

SPIT and QUAC

Special Interest Troupe and the Queer Artists Union Collective

Ann Marie Wierzbicki, of the Metro Labour Education Centre of Toronto, coordinated the 125th Anniversary celebrations of the Labour Council of Metro Toronto and York Region. With a background in theatre, she sought out popular theatre artists for the celebrations. Aida Jordão came on board as project artist and with Ann Marie brought unionists and activists together to learn the skills of forum theatre for use in future union activities. Over three months, she worked with nine participants from different unions to create a play for the Labour Council anniversary. The role of the artist, says Aida, is to "teach the skills; the content is theirs. You shape it, you direct it, but they are responsible for the content." The result was a participatory play, *Picking Us Off One by One.*

Several members of the troupe continued to work together after the anniversary celebrations and called themselves SPIT or Special Interest Troupe. They performed at a CUPE Conference on Human Rights as well as at the CLC North American Educ-Action Conference in 1997. Their memorable characters include Polly Tishun, the Morning Nafta Pill and Global Headhunters.

Aida Jordão, Gay Bell, a theatre artist and member of CUPE 4400, and Stephen Seaborn, a member of CUPE 4440, formed another arm of this incredibly creative troupe. They called themselves QUAC, or Queer Artists Union Collective, and were a huge success at the 1997 CLC Pride and Solidarity Conference.

Both Aida and Ann Marie view forum theatre as an effective means for unionists to express social and political ideas. It allows them to be both performers and participants in the creative process. It also encourages theatre workers and unionists to exchange information and experiences.

SPIT, *Picking Us Off One By One*, Forum Theatre, Labour Council of Metro Toronto and York Region 125th Anniversary

From Picking Us Off One by One
(To the Tune of "Mary Had a Little Lamb"):

Mary had a busy job
She never missed a day
Then Mike Harris came along
And took her job away
Now she's lost her house and home
She's really in a jam
So she packed her bags and left
She took it on the lam.

Flippin' In

A play on youth and fast-food workers by Anne Chislett and Young Peoples Theatre

Maja Ardal, Artistic Director of Young Peoples Theatre in Toronto, commissioned Anne Chislett to write a play for professional actors about youth workers, the fast-food industry and the heroic efforts of Sarah Inglis. The result was *Flippin' In*, a show which earned the 1995 Chalmers Award for Anne Chislett.

Sara Inglis is a young woman who went head-to-head with MacDonald's in Orangeville, spending enormous amounts of time and energy in her attempt to unionize her workplace. While the play is a fictitious account of youth workers at a fast-food restaurant, their poor working conditions and attempts at unionizing, it is loosely based on the actual experiences of Sarah Inglis. The young workers are shown being berated by their boss for not working fast enough. Audience members are treated to lively debates by the burger flippers on whether to organize or not. The story finishes with an upbeat message on the benefits of unions as the cast marches and sings songs of solidarity.

Flippin' In first toured to many schools in southwestern Ontario. It was later presented at the 1995 OFL Convention. The allotment of time for the play, during a busy day-time convention agenda, showed that popular theatre can be considered an important and effective tool for the presentation of union ideas and concerns.

A group called Ground Zero then took over the production of *Flippin' In* and toured it to school groups and labour councils throughout the province. Eventually, the show drew an angry response from the Ontario Restaurant Association which stated that it was encouraging high school kids to unionize. As fast-food workers and audience members might say, the facts speak for themselves. In 1992, there were 40,000 fast food outlets in Canada with

Flippin' In cast characters (Photos Tom Sandler)

little protection for their workers. In light of these numbers, Sarah Inglis was certainly a brave young woman.

Life on the Line

A play with songs by David Archibald and members of the Kingston and District Labour Council

From We Shall Stand As One

Standing for the workers on
 the picket line today
Standing for the women and
 their fight for equal pay
And a million jobless people
 living life under the gun
Tell us we must stand as one

David Archibald

S et during a fictitious labour council meeting, *Life on the Line* was first presented at the Steelworkers Hall in Kingston on April 27, 1989. Based on interviews with union members in the area, the fifty-minute play is both humorous and insightful. It begins with members searching for lost meeting minutes while they discuss important union issues of the day. The play continues with vignettes and songs about pay equity, workers' compensation, plant closures and the right to have a contract. One segment expresses mixed feelings about federal government intervention in a postal strike; another explores tensions between the former Letter Carriers Union of Canada and the Canadian Union of Postal Workers (CUPW).

Rank and file union members were involved in the development of the play from the very beginning. They were also the cast members. The audience was delighted by a cast of characters including a PSAC negotiator and members of CUPW as well as many other union locals. The *Kingston Whig-Standard* said that the actor-members brought an "appealing sincerity" to their roles.

Life on the Line took on a second life when David Archibald was given the distinction of being the artist-in-residence at a local high school. The students added a section about part-time youth workers and presented the play to enthusiastic crowds at a number of high schools in the area.

From Blame the System

You don't believe it now
you're on the street
You may be shaking some,
but don't admit defeat
And why it happened,
you'll never understand
But there are people here
to lend a helping hand
(Oh it gets better now, it
just takes time)
You lost your job, boy—
that's no crime.

David Archibald

The Kingston and District Labour Council Presents
An Original Work of Music/Theatre

LIFE ON THE LINE

by David Archibald

A Musical Satire on Working Life in Eastern Ontario

Drawing for *Life On the Line* program flier, artist unknown

The Brooks Project

A play produced by the Canadian Artists Workshop (Patricia Hennesy Laing, Director) with CAW Local 444

by Patricia Hennessy Laing

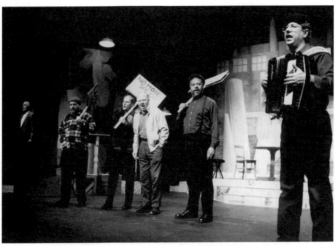

Premiere of the play *The Brooks Project*, Windsor, 1997

When I approached the CAW with an idea for a project that would celebrate labour and at the same time assist with the development of a professional theatre company for the Windsor region, members of CAW Local 444 suggested that we explore the story of Charlie Brooks, the first President of the local.

Charlie Brooks was a dynamic leader of Local 444 and a driving force behind the establishment of one of labour's first credit unions and labour's involvement in the Red Feather Campaign (now the United Way). In addition, he led the way on health and safety and training issues and on pensions and wage parity.

Rex Deverell was commissioned to write a script and throughout 1995 we researched the history of the union and the role that Charlie Brooks played in it. We conducted an exhaustive series of interviews with labour leaders on a local, provincial and national level, many of whom had become active through Local 444. Interviews were also conducted with many CAW retirees, Chrysler executives, community and family members.

I directed a reading of Deverell's first draft of the play, performed in Toronto early in 1996 and later at the Local 444 union hall. All union and family members who had participated were invited to the reading in Windsor. It was an intimate and powerful event, with many actors playing characters who were in the audience that day. A lengthy and lively discussion followed.

The play was produced again in 1997 with the support of Local 444 and Chrysler Canada

Tomas Hauff as Brooks and Phyllis Lewis as Fran in *The Brooks Project*, Windsor, 1997

and it was thought that about eighty percent of the 3,000 people who attended were first-time theatre goers. A staged reading was presented at the CAW Education Centre in Port Elgin in 1998. A national tour is tentatively scheduled for the Spring of 1999.

Patricia Hennessy Laing is a theatre director and choreographer on faculty at the University of Windsor, School of Dramatic Art, and a founding member of Canadian Artists Workshop.

Postscript

A play produced by the theatre collective Rehearsal in Progress with CUPW Local 590, Peterborough

by Robert Fortin

A group of theatre workers saw that no one was telling stories or dealing with issues that spoke directly to the people in their community. Our first production, The *Pioneer Chainsaw Massacre*, was about the closure of Peterborough's Pioneer Chainsaw plant in 1987. We called our company Rehearsal in Progress.

The post office was a ready-made subject as one of the collective members also happened to be a postal worker. Meetings with posties also impressed on us the urgency of the story. There had been a nasty strike and there was rumbling about lay-offs, mechanization, and privatization.

We set the play on the picket line for, after all, that is where most of the issues come into sharp focus. The set was a piece of chain-link fence and a brick wall. On the wall was an oversized postage stamp, actually a screen on which images were back-projected. The play presented as realistically as possible the bizarre experiences of being on strike—the boredom, the danger, the humiliation and ultimately the sense of pride and power that comes from carrying a picket sign. We also knew that workers' views are rarely unanimous and to present them so would be merely writing union propaganda. As a result, picketers were allowed to bicker about the efficacy of the strike as a negotiating tool and to give voice to their reservations about the union leadership. We—Rehearsal in Progress—were also careful to make the doubters' arguments strong. Debate is healthy, the play said, but in the end the workers' differences are overshadowed by their common interests. This was proven in the adverse conditions of the strike.

Interlaced with the picket line scenes were songs and stories. "The Dream of Harvey André" satrized the post office's obsession with mechanization. Indeed, some of the funniest lines in the play were quoted verbatim from Canada Post literature.

We presented *Postscript* in Toronto, Cobourg and Peterborough. A later show at the CUPW national convention, to a large audience of pumped up posties, stands, for several members of Rehearsal in Progress, as a career highlight.

Scenes from *Postscript*, Rehearsal in Progress, 1989

Robert Fortin is an actor, writer and member of CUPW Local 590 in Peterborough.

Writing

It is my belief that the only real creativity in this world comes from people in communities who resist any attempts to limit or bind the human spirit. When people have the audacity to assert new possibilities for their lives, that is the energy that fuels all creativity, that fuels the artists and industry. That energy, I believe, is the lifeblood of the artist and that fact, I believe, artists have yet to discover.

As artists and workers we share values for decent working conditions, fair wages, justice, compassion, a healthy planet and a good future for our children. After all, we are community.

Lillian Allen,
poet, community activist and past Mayworks Festival coordinator

Artists in this section:

Charlie Angus and Brit Griffin

Stanley G. Grizzle

Rick Salutin

Phil Hall

Ed Thomas

Ron Dickson

Angels, Wildcats and Highgraders

Northern Miners in many media

by Charles Angus and Brit Griffin

We moved to Cobalt in 1990 at a time when the local mining economy was collapsing and the community, like many resource towns in northern Ontario, was facing a serious crisis in identity. What kind of future would there be without the mines? As well-paying blue collar jobs are downsized or lost because of resource depletion, questions about the viability of these communities cannot be overlooked.

We attempt in our work to articulate the cultural identity of the North, of communities which have a very different cultural and political history than the urbanized south. We believe that the problems besetting rural/industrial Canada are as much social as economic. The cultural undervaluing of resource communities is reflective of the underlying colonial relationship between the north and the south.

Wildcat: A musical drama/comedy

In early 1996, we set out to interview miners and their families and develop a play with music that would articulate changes that were occuring in northern mining culture. The result was a one-act play *Wildcat*, that examined the tensions between three generations in one mining family.

Joe Menard is a 45-year old miner, worried about his own future in a downsized industry, caught between the memory (and ghost) of his father, the legendary Big Gord Menard who organized the mines and smelters of Smeltertown in the 1940s, and the lost dreams of his son, Darren. Through Darren, *Wildcat* articulates the struggle of young workers who are being shunted around in the new economy of contract work and low-paying service sector jobs. Joe Menard must choose whether to support the young rebels or continue his habit of trying to keep a low profile. The play does not resolve the issues it raises but examines the changing realities of work and what it means for resource-dependent communities.

A first draft was written in early 1997 then critiqued and workshopped. In the summer, the final draft was prepared. Producer Susan Meurer worked hard to get a commitment from organized labour for a full production. Although the play received support within the Steelworkers, it was hard to pin them down to a financial commitment. In the end, a dramatic reading of the play was staged in Sudbury in March, 1998, as a fundraising event for striking miners in the town of Red Lake. Ron Tough, a former hardrock miner, directed a cast of local Sudbury actors.

Wildcat's dialogue is fast and biting and it could be performed for students, union groups or general audiences anywhere.

The Menard family played by Rudy Lindbergh, Ron Tough and Matt McLean, from the play *Wildcat* (Photo Angus/Griffin)

Waiting for the Cage: A CD and CD-ROM by The Grievous Angels and producer Scott Merritt

Waiting for the Cage is the fourth release by the folk-rock band the Grievous Angels. A hard-edged look at life in the smelter and mining towns of Northern Canada, it is a journey through a land of long winters and tough dreams.

This project also began when Charlie Angus interviewed numerous miners and their families in mining communities that included Elliot Lake, Timmins, Cobalt, Sudbury and Kirkland Lake; some were held in the homes of mining widows, others in bars or in mine headings 4,800 feet underground. Some of the songs are based on interviews with survivors of the Kirkland Lake strike of 1941.

In 1995, the Grievous Angels went into the studio to put some of these stories to music. As the CD—ten tracks of original music—neared completion the project took another turn. Rick Conroy, then piano player for the Grievous Angels, began work on a CD-ROM component along with Michelle Gay. Each of its nine sites, or songscapes, was developed by a different artist. The CD-ROM contents are based on photos, taped interviews and materials gathered by Angus. Many of the photos are by documentary photographer Louie Palu.

Waiting for the Cage won first prize as the top Interactive CD-ROM in the world at the 1996 Festival of Short Film and Interactive Media in New York City. The CD-ROM has been highly acclaimed as a leading example of the possibilities of interactive technology and art.

Publications

In 1995, we founded *HighGrader Magazine* to examine many of the fundamental issues—cultural and political—facing working people in the North.

We Lived a Life and Then Some: the Life, Death and Life of a Mining Town, written in 1996, examines the oral culture of Cobalt and is

Sub shop workers: Fionna Tough, Alicia Tough, Jen Comacchio and Melissa Duggan, from the play *Wildcat* (Photo Angus/Griffin)

Actors Michael Shepherd and Rudy Lindbergh as mining partners Donny Dupuis and Joe Menard from the play *Wildcat* (Photo Angus/Griffin)

illustrated by Rob Moir and Sally Lawrence. More than a mere local history, it uses the Cobalt experience as a reflection of the broader culture of hardrock mining communities.

Image from the CD-ROM *Waiting for the Cage*

Charlie Angus has completed a collaboration with documentary photographer Louie Palu chronicling mining landscapes in Northern Ontario and Quebec. It is published as a book titled *Industrial Cathedrals of the North,* available from Between the Lines.

Charlie Angus and Brit Griffin are writers who live and work in Cobalt. They publish Highgrader Magazine *and work on various cultural projects in Ontario. Charlie Angus is the lead singer in the band The Grievous Angels.*

Image from the CD-ROM *Waiting for the Cage*

My Name's Not George: The Story of the Brotherhood of Sleeping Car Porters in Canada

A book of personal reminiscences by Stanley G. Grizzle

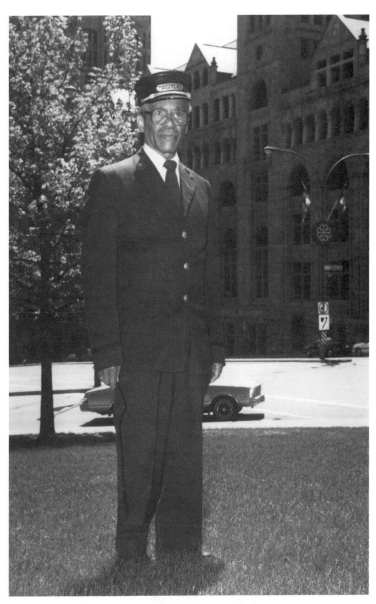

Stanley G. Grizzle in archival CPR sleeping car porter uniform, standing in front of the Windsor Railway Station, Montreal, 1987 (Canadian Pacific Archives)

For twenty years, Stanley Grizzle was a sleeping car porter on the Canadian Pacific Railway. In his book *My Name's Not George* he describes the lives and times of African-Canadian men working on the trains, once one of the few steady jobs available to them. He tells the story of the Brotherhood of Sleeping Car Porters, the first trade union organized by and for Black men in Canada. Stanley Grizzle later became a Judge in the Court of Canadian Citizenship, the first African-Canadian in the Court's history. He has received many honours, including the Order of Canada.

In his book, he explains its title: "We had no identification to wear and passengers often addressed us as "George" after George Pullman ... This always got my back up and it irritated many other men as well. I would always correct them by calmly saying 'My name's not George.'

Later, our Brotherhood negotiated with the company to have each porter issued with two plastic name cards, placed in wall holders at each end of the sleeping car to invite the customers to call us by our names."*

*Stanley G. Grizzle, *My Name's Not George: The Story of the Brotherhood of Sleeping Car Porters in Canada, Personal Reminiscences of Stanley G. Grizzle* (Toronto: Umbrella Press, 1988), p. 39

Winning Back Art

A Creative Writing Workshop with Rick Salutin and members of CAW Local 1989

One of the first workshops held in 1988 at the newly created CAW Family Education Centre in Port Elgin was a creative writing workshop. The participants were from a wide variety of backgrounds and included a foundry worker, a fisher, a local union president, an airline passenger agent, an assembly line worker and an office worker. What they shared was a love of writing.

The workshop leader, Rick Salutin, is an award-winning playwright, journalist and novelist, who has worked extensively with the trade union movement and in the anti-free trade fight. Rick expressed some of his views on culture: "A genuine workers' culture doesn't just mean well-intentioned middle class artists producing art for workers ... That approach can treat workers simply as consumers of culture and leave them out of the production process."*

Over four days, the participants examined various forms of fiction and non-fiction writing. The main activity however, was their own writing. Rick met at length with each of the unionists, providing feedback and encouragement. On the last morning, each writer read from his/her own work to the rest of the class.

The participants returned to their workplaces with a new-found confidence in writing as a means both for creative expression and for political organizing.

Ripples
Glenda Winter, FFAW/CAW, Trepassey, Newfoundland

White crests on the water
Flickering scenes
Each one a memory
Of something past
Just fleeting glimpses
Of somebody's dreams
One for the fisherman
Who lost his life
One for the man who's still
 trying
Waves toss you
and turn you
they try to drag you down
but white crests keep
 coming
Only to be broken
by a fisherman's boat.

Winning back art:
A CAW Creative Writing Workshop

CAW ⬥ TCA
CANADA

Brochure for *Winning Back Art*; Drawing by Gail Geltner

*Quotation and poem from the CAW *National Union Magazine*, (Summer 1989) pp. 15, 26

Liquid Lunch

A Writers' Project with the CAW

by Phil Hall

The title, of course, confessed the focus of the workshop from the very start: the boozehound as working class bard. It was a subject-specific series of get-togethers, an attempt to introduce artistic angles into the CAW's Substance Abuse Program. The union invited me to Port Elgin to read and sing and joke and listen to national delegates at a Substance Abuse Conference and then I was sponsored to go to Windsor to conduct Saturday morning writing workshops. Most of the folks who came out for the sessions were senior union members and senior drinkers now sober. My impulse, faced with these wisened elders, was to shut up and listen. So I mostly did that, but I brought samples of the New Work Writing from the Vancouver Industrial Writers' Union anthologies and from books of work poems compiled by Tom Wayman. The poems themselves sparked discussion, new stories: drinking on the job, the tricks of deception, almost getting fired, the despair, how important the job and the union became when sobriety began, renewed hope, all that.

The story that still haunts me is about a man boiling down old 78s—vinyl records—to get the alcohol out of them, the whole house full of blue smoke.

Those who came to the workshop seemed to be pleased with themselves when they saw their memories on paper, when they heard the rest of us laughing and agreeing. Out of the workshop came a small anthology, also called *Liquid Lunch*. The creative fellowship of these elders, these writers, eventually helped me to also stop drinking. Useful. Our words are. Tools.

Liquid Lunch Limerick
W. J. A.

When you're ready, just call on your rep
That's a substance abuser's first prep.
Kickin' habits are tough
But we've all got the stuff
If we help ourselves take that first step.

Old Whiskey and Wine
Nancy L.

It took time to reach the bottom
Made it my life's career
Worked very hard losing
Hurting ones that I hold dear.

I know now what hell looks like
It's where I spent most of my time
Had lots of help getting there
From my friends whiskey and wine.

They say when you reach bottom
The only place to go is up
Getting rid of those pink elephants
Before you reach the top.

It sometimes takes losing
All that you hold dear
Spending time in your own hell
Without old whiskey and beer.

Taking each day one at a time
Mending the pain you've caused
Refusing the friendship of
Old whiskey and wine.*

Phil Hall is a writer and poet, (Amanuensis, The Unsaid, Hearthland) and publisher (Flat Singles Press

*Poems from *Liquid Lunch*, CAW Substance Abuse Committee (Port Elgin: CAW Publications, 1990), pp. 3, 8

The Crest of the Mountain: the Rise of CUPE Local Five in Hamilton

A book by Ed Thomas

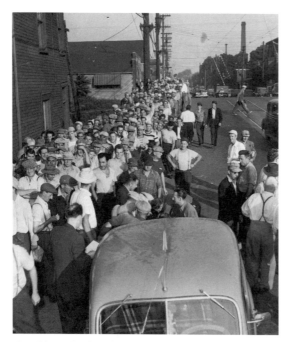

Outside strike headquarters, August 10, 1950. Striking Local 5 members wind their way down the street toward the Barton Street jail in the background (Courtesy Mrs. F.O. Rogers)

Hamilton's jazz band, The Washingtons, entertain striking members of Local 5 (Courtesy Hamilton Public Library, Special Collections)

In 1989, Ed Thomas, a long-time member of CUPE Local 5, enrolled in the workers' education program Literacy in the Workplace to improve his spelling. When he discovered some old photos of past members, Ed was inspired to document the history of the local as a class project. Originally designed to be a pamphlet, the project blossomed into a book which he called *The Crest of the Mountain: the Rise of CUPE Local Five in Hamilton*. It documents in words and pictures the rich history of CUPE Local 5 since 1918. The book draws parallels between the history of the local and historical events that occurred in Hamilton since the 1800s.

One such event was the execution of Hamilton murderer John Vincent, sentenced to death in 1828 for the murder of his wife. As no executioner was available, another prisoner was asked to do the deed. Unfortunately, the co-prisoner was not an experienced executioner and the defendant's demise was met only after a first failed attempt at hanging. Ed Thomas sees this tragedy as an example of a long tradition of the hiring of contracted labour in Hamilton, labour which is unfit to perform the tasks at hand.

Ed has sold most of his initial print run of a thousand copies of *The Crest of the Mountain*. He has also completed a second project, *A Worker's Guide on Doing a Local Union's History*. It provides information on research methods and resources, funding and publication guides. *A Worker's Guide* is a co-publication of CUPE National and the OWAHC in Hamilton.

Ron Dickson: Poet of the Canadian Auto Workers

From Phil Hall's Introduction to Ron Dickson's chapbook of poetry, *The Sorrow of Pickets*:

Originally from Scotland, as the brogue makes obvious, Ron Dickson, now of Windsor, is a legend of generosity and solidarity and creativity within the CAW in Canada. Originally a worker at the Hiram Walker Distilleries, he is currently a CAW National Representative. In reading the words of Ron's poetry you can visualize him marching ahead of the banners in the Lorraine Segato's video *Good Medicine.**

Reporter Don Lajoie, writing about Ron's poetry in *The Windsor Star*, quoted him as saying,

I was born in a small, obscure, coal-mining village in Scotland. There was only one choice for the working class. It was the coal mine or starvation. For me, books became a natural means of escape.

When I do these readings (of poetry) I always feel pretentious. They also make me nervous as hell. The first time I did it, I must have sweated off about ten pounds.

I'm still trying, still searching to write one marvelous paragraph. One I can still stomach the next morning. Raymond Carver (the American writer) said he had to decide whether he was going to be a writer or a reader. I haven't decided yet.

Ron has read his poetry at many union gatherings and at the Mayworks Festival. Ron also works with the substance abuse program at the CAW and has made many presentations to union locals on the issue. He is also on the Board of the Mayworks Festival.

The Sorrow of Pickets

And when it was over
the crowd withdrew
some to small houses
with cracked chimneys
and wooden floors
stained with the sorrows
of false starts.

Regret and evasion
as habits grew—compelling
social indignation
to connect hands
in desolate assemblies
On busy city streets
indifferent passersby pushed
impatiently against us

as if to say, "So what
is your pain to me?"

A demonstration at Queens Park from the video *Good Medicine*

*Ron Dickson, *The Sorrow of Pickets* (Flat Singles Press, 1998)

Sculptures, Paintings and Murals

"Yes, it is bread we fight for but we fight for roses too." We fight on economic issues but we must include beauty, art and music in our struggle for human dignity.

Evelina Pan,
President, Thunder Bay and District Labour Council

Artists in this section:

Rob Moir and Sally Lawrence

Keith Meadows

Maureen MacKay

cj fleury

Tony Cooper and Paul Kovanen

Charlie Stimac

Dave Robinson

Bob Kell

Carl Wesley Jean

B.A. (Bobbi) Wagner

Mike Duquette

Mike Constable

Windsor Printmakers Forum

The *Tribute to Miners Sculpture*

A sculpture for the Miners' Memorial Foundation, Kirkland Lake

by Rob Moir and Sally Lawrence

In the Fall of 1988, we were on our way to meet with Steve Yee of USWA Local 4584 to discuss his dream of erecting a monument to local miners who had lost their lives to mining. As we skidded over the frozen surface of Kirkland Lake's tree-lined highway, hard rock miners grappled with the perils of heat exhaustion one mile below.

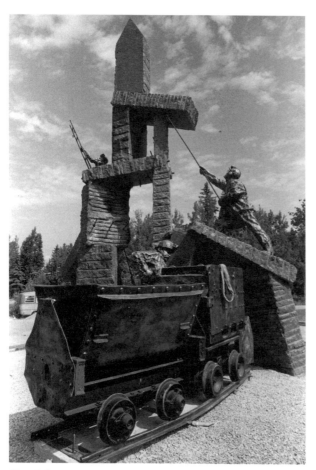

The *Tribute to Miners Sculpture*, Kirkland Lake (Photo Walter Franczyk)

Soon after, dressed in yellow oilers, knobby steel-toed boots and hard hats with lights on them, and packed into a cage with miners who joked of frayed cables, we went down the deepest timber shaft mine in North America. Sally hoped that by facing her fears she would understand the terror many of these men experience and the courage and restraint they require to continue. For months, these men never see the sun; moreover, their lives are in danger all the time from environmental disease or from a rock-burst which would fell tons of rock, turning the tunnels into tombs.

Our two trips underground and interviews with the miners showed us that a "miner type" does not exist and that such myths only produce caricatures. The emotional and physical diversity of the men could not be expressed in one figure. By making portraits of five Macassa miners working with actual mining equipment, we hoped to capture the universal through accurate observation of the specific.

The men had many motives for staying on the job and often made comments like, "The best way to see Kirkland Lake is in your rear-view mirror" and "Only whores and hockey players come from there." Yet there were those who truly embraced the discipline and technique required to wield a jackhammer drill or a mucking machine. In fact, a miner named Herb Boudreau demonstrated his work with such ease and grace that we asked him to model for one of the figures. He also became a member of the Miners' Memorial Foundation (MMF) and was instrumental in the installation of the completed sculpture. We wanted the final design to celebrate the strength and skill of the miners while depicting the working man as a work of art. Its location should be a sacred place and a focal point for the community.

The monument stands on an outcrop of bedrock in front of Sir Harry Oakes' Chateau at the entrance to town. Blocks of local black granite suggest a mine's head frame, a mine shaft, and the many levels of a mine's shafts and tunnels. The structure serves as a stage for the lively figures of miners which contrast

with the heavy geometric solemnity of the stone.

For the figures, recycled mild steel was forged, welded, and finally spray brazed with bronze to prevent galvanic corrosion. The gold colour connects the miners' lives to the ore and establishes them as the mine's most important resource. Where the rough quarried blocks have been polished, fossil-like reliefs shadow the poses of the figures—like ghostly memories carved in stone.

We worked with the MMF to raise funds, selling Nevada tickets at the mall, hosting many midnight bingos, and organizing a Rita MacNeil benefit concert. When the audience stood together singing "The Working Man Song" with Rita, miners openly wept as they embraced their families and friends.

During six years, friendships were made, lost and remade. One problem was the reconciliation of different approaches. We, the artists, viewed the process as an organic and ever-changing journey without a map. The unforeseen was not only expected, it was often embraced. The MMF was necessarily task oriented and frustrated by the unpredictable schedule. The rock structure was repeatedly redesigned because of unforeseeable events: the original rock was stolen, new material fractured and, finally, block sizes were determined by the equipment and financing available, not design choices. The MMF was concerned about community perceptions and therefore wary of any changes in direction.

Furthermore, the defining and delegating of responsibility was often frustrated by procedural and personality conflicts. Many of the MMF's volunteers found the logistics for such a huge project daunting. At the same time, we assumed too much responsibility without acquiring control and began relying heavily on the financial

The Stoper (Photo Ruth LeBlanc)

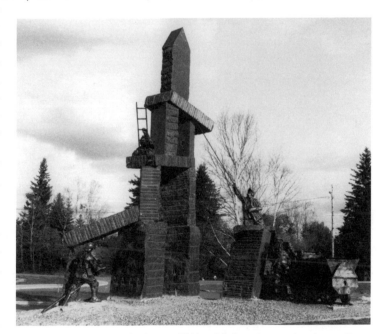

The *Tribute to Miners Sculpture,* Kirkland Lake (Photo Walter Franczyk)

support of family and friends, donating time and resources we could not afford. Inevitably,

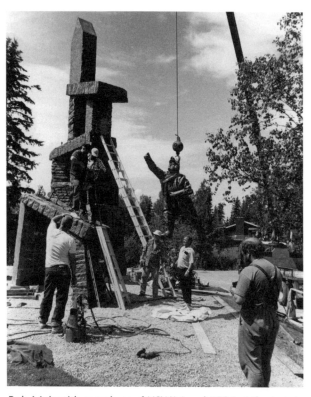

Rob Moir with members of USWA Local 4584 at the installation of *Tribute to Miners Sculpture* (Photo Walter Franczyk)

Miners lay a commemorative wreath at the dedication of the *Tribute to Miners Sculpture,* 1994 (Photo Walter Franczyk)

such unprofessional behavior led to a deadlock between the MMF and the artists.

Much was solved when the MMF delegated responsibility and control to liaison people who improved communication with the artists while focusing on the common purpose. Optimism was pumped back into the project after a new committee was elected. We opened contract negotiations with the MMF and no task was undertaken without a signed agreement and firm pay schedule.

On July 24th, 1994, nearly six years after that first trip underground, we joined the MMF to celebrate the unveiling of the *Tribute to Miners Sculpture.* The ceremony coincided with Kirkland Lake's 75th anniversary. Over four hundred people endured the pouring rain to witness miners laying wreaths of sunflowers honouring co-workers who had lost their lives. The recent deaths of local miners Robert Sheldon and Leonce Verrier made the opening even more poignant.

Every April 28th, the sculpture is a meeting place for the National Day of Mourning for workers killed or injured in the workplace. In 1998, the union erected three granite plaques at the site commemorating all those who have perished in local mines.

The *Tribute to Miners Sculpture* has become a tourist attraction and a gathering place for community activities. It serves as a backdrop for Christmas caroling, summer picnics and even wedding photographs. Canada Post reproduced a detail of one of the figure's heads on the envelope for a stamp that commemorated mining in Canada.

We believe that the experience of delving deep to raise awareness of the miners' plight was much like our trips underground—frightening, challenging, sobering, and rewarding. We have learned to regard with much respect the working men who have supported their community from below.

Rob Moir and Sally Lawrence are artists now living in Waterloo. They enjoy depicting Northern Ontario's uniqueness in metal, wood, stone and paint.

Fallen Worker

A sculpture by Keith Meadows for the Durham Regional Labour Council

by Keith Meadows

In 1996, the Durham Regional Labour Council commissioned a monument to honour the memory of our sisters and brothers who were injured or fatally injured at the workplace. It stands on the grounds of Oshawa City Hall. I designed the three-sided column which was built by Bobby Watt and the stonemasons of the Guild Institute.

Relief panels on two sides of the monument show a fallen worker. The third side contains two smaller relief panels. The upper shows a pair of cupped hands holding a dead

Back view of the monument *Fallen Worker*, carved limestone, 4' x 4' x 8', Keith Meadows, 1996

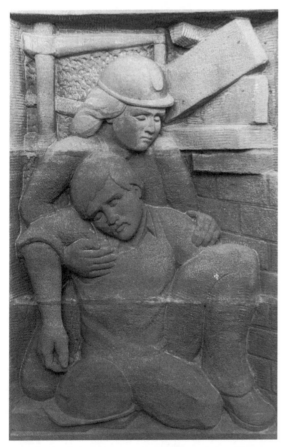

Detail of relief sculpture depicting an injured worker, Keith Meadows, 1996

canary, as the canary is the international symbol of the fallen worker. The lower relief bears the engraved inscription, "Mourn for the Dead, Fight for the Living." These words are recognized internationally and used at Day of Mourning ceremonies worldwide.

To watch a design transform from a few rough sketches into the beautiful structure standing at City Hall is something an artist dreams of. I saw this dream became a reality.

Keith Meadows is an artist and member of OPSEU Local 301 in Oshawa.

Day of Mourning Monument

A sculpture by Maureen MacKay with USWA Local 2251

by Jonathan Forbes

Sculptor Maureen MacKay worked with a group of members USWA Local 2251 at Algoma Steel in Sault Ste. Marie to create a monument that honours workers who have been injured or killed on the job.

The artist interviewed local members, including some who had been injured while working. Members attended workshops to look at the elements of the work and at drawings before deciding on a final design. The sculptor learned about the technical processes in the plant and the members, in turn, got a chance to use their creative skills in pattern-making, sandcasting and welding the final work.

The finished sculpture, two cast pattern shapes with the incorporation of a sandcast relief, is an impressive testament to their combined skills and artistry. It is now installed in front of the Steelworkers Hall in Sault Ste Marie.

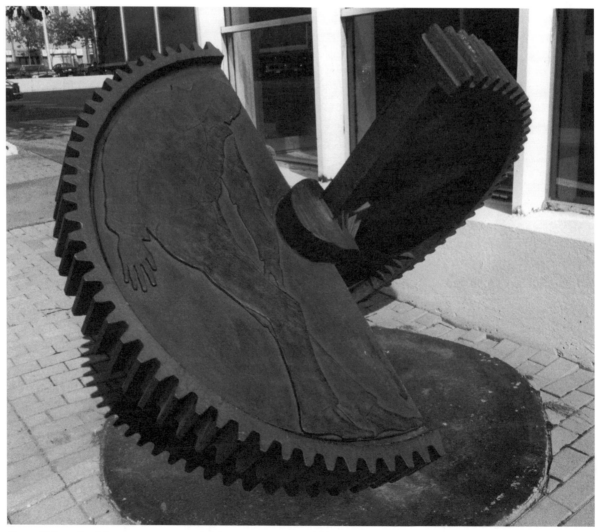

Day of Mourning Monument, cast steel, Maureen MacKay, 1989 (Photo Vince Pietropaolo)

The Mechanics of Gauging a Trade

A sculpture by cj fleury and members of the Ottawa Buildings and Equipment Facility/Municipal Workshops

cj fleury, sculptor, Paul Watt, structural welder and Larry Whitty, stores worker, discussing project plans (Photo Paul Curtis)

In 1994, cj fleury was selected, under the Ottawa Art in Public Places Program, to create a new work of art. It would be made in conjunction with the workers at the new Buildings and Equipment Facility/Municipal Workshops in Ottawa—engineers, mechanics and maintenance workers. Since the piece was to reflect their work and lives, facility workers were included on the selection committee.

cj was provided with on-site facilities and worked for ten months to complete an outdoor sculpture. She spoke with over 200 workers and developed a model from thousands of "snippets of dialogue." After the workers approved the final design, she worked with the welders and body shop workers to construct and install the sculpture. The artist shared her knowledge of producing public art with the facility workers and they shared their ideas about art with her. They also discussed their job training and backgrounds and their reasons for working together. They analyzed and compared their work-

Municipal Workers Constructing *The Mechanics of Gauging a Trade* (Photo cj fleury)

ing methods and productivity. It took some time for the municipal workers to consider an artist as a co-worker but eventually, as cj says, the workers saw that "art could be made about work and … that art could actually *be* work too." For cj, working with the municipal workers led to thinking about "how knowledge comes to be held, shared, and shaped," and "what the

The raw steel arc during construction (Photo cj fleury)

role of the artist is." She also developed a deep appreciation of industrial imagery such as the "beauty in the stores of mechanized units."

The final piece (see colour section) is a chromed and oxidized steel sculpture, 10 x 22 x 17 feet. Three ten-foot long chromed tools are partially encircled by a massive gauge. The piece portrays the tools used in the work at the yard and refers to the repetitive, cyclical nature often found in trades work.

Paintings of Steel and Strength

A multidisciplinary mural by Tony Cooper and Paul Kovanen and members of USWA Local 6571, Lasco Steel, Oshawa

In the early months of this project, up to thirty USWA Local 6571 members, their families and union retirees enrolled in painting classes that Tony Cooper and Paul Kovanen, a member of the local, offered as part of the project. After painting skills had been developed, Tony noted, "a very fine, professional body of work was being produced" and the group began in 1996 to design a collaborative mural for the union hall.

First, some members photographed and videotaped the plant steelmaking process. Then they painted industrial scenes and chose the ones that they felt were the most powerful. Members also painted images of the local landscape and environment.

The result was a steel angle-iron construction that held a series of paintings by members of the group. The mural, located in a very busy union hall in Oshawa (see colour section), is viewed by hundreds of people each year. As Tony Cooper points out, "a very spartan interior (now) has a dynamic and rich focal point that enlivens and humanizes this important meeting place."

Detail, USWA Local 6571 Painting Project

Painting the Worksite

A mural by Charlie Stimac with the Northumberland and District Labour Council

Charlie Stimac has been a steelworker in iron, brass and copper foundries in Guelph and Toronto. Many of his paintings are about the steel industry and the struggles that have taken place there. He has painted slag dumping in Sudbury, an open pit mine in Marmora and has created several strike support posters, notably for the 1981 Stelco strike in Hamilton and the 1984 Eaton's strike in Toronto.

Charlie came from a union family in Detroit but left the U.S. to protest the Vietnam War. After working in foundries for many years, he settled in Gore's Landing, near Peterborough, where he completed a mural and a series of paintings and drawings for the Northumberland and District Labour Council. He was able to pursue his art for a number of years before the onset of multiple sclerosis.

The mural depicts workers in different plants in the area. Charlie sketched on location at General Foods, Columbus McKinnon, Complex (see colour section) and in the boiler-room at a public school. He used the drawings as the basis for the four-panel mural, each section depicting one of the plants.

John Lindsay, the model for the public school custodial worker, convinced his union local to support the project. He was quoted in the Cobourg *Daily Star*. "Having the average individual doing work (in art) is something everyone can relate to. It shows the nine-to-five crowd, the shift workers … When people think of art, they may envision landscape, or wildlife," he added. "People are included as a small part of it. But in Charlie's work, the worker is the subject. And the environment is his environment, his working environment."

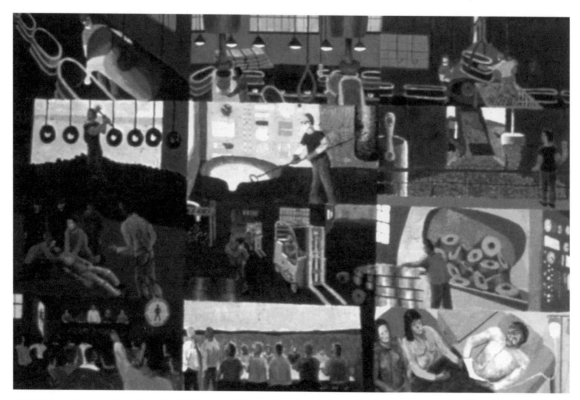

Autobiography of an Iron Foundry Worker, acrylic on wood, 3' x 4', Charlie Stimac, 1983

Fire Fighters' Mural

A mural by Dave Robinson with the Toronto Fire Fighters' Association

The Toronto Fire Fighters' Association headquarters served as the Ashbridges Bay Fire Hall #30 from 1922 to 1980. Currently it sits surrounded by industrial lots, many abandoned because of pollution. Other neighbours include film studios, warehouses and recycling plants.

Dave Robinson was commissioned by the Fire Fighters' Association to paint a mural on an outside wall of the building where a deck is situated. The idea was not only to offset the bleak surroundings but to portray dramatic aspects of the job and of firefighting history.

The mural is a collaborative project between Dave and the Association. Members contributed ideas for the composition and content of the mural and assisted with the preparation and priming of the mural space. They also provided archival photographs and materials showing older machines and facilities. Painting took place during the summers of 1996 and 1997.

The ornate and colourful mural (see also colour section) is seen by Association members and also members of the public who rent the hall for events and celebrations. It is not only a testament to the work that firefighters do but also to the collaborative efforts between their association and the artist.

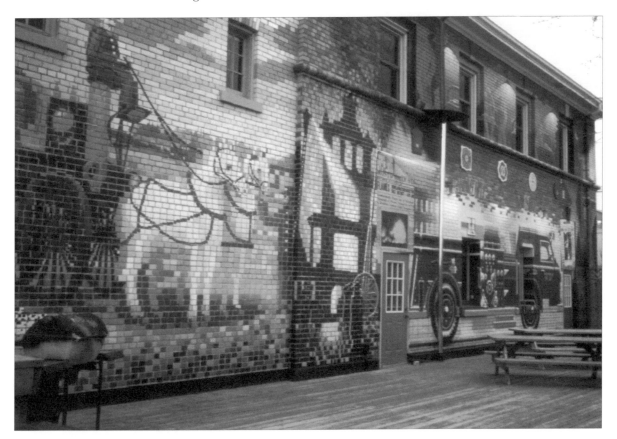

Detail: *Fire Fighters' Mural*, Dave Robinson, 1996–97

OPSEU Mural

A mural by Bob Kell with OPSEU

by Jonathan Forbes

Poster for the series *Winnipeg General Strike*, 1919, offset, Bob Kell, 1980

Bob Kell had thought about creating a mural for OPSEU, his union, for a number of years. One day, he says, "I heard my son playing a recording by Billy Bragg of 'Power in the Union,' a traditional labour song, and I wanted to use the lyrics."

So began Kell's plan to create a permanent monument to the large OPSEU membership. Working in co-operation with four union members, Kell went through a careful process of discussing the aims and objectives of the work, the planning of the design and finally the execution of a large, portable mural. Each of its five panels measures seven feet by three feet. The artist wanted to make something that looked like an electrical current that would connect the experiences and energy of OPSEU members. The mural was unveiled at OPSEU's Queen's Park offices in Toronto during the Mayworks Festival in 1989. It now hangs at the main OPSEU office in Don Mills (see colour section).

Bob sees the mural as growing from the work on the Winnipeg General Strike that he had started years earlier. Based on photographs from the strike, paintings and posters portray aspects of the struggle in a tribute to the strikers and as a depiction of the struggle that continues today.

Working Life

The paintings of Carl Wesley Jean, member and past President, CUPE Local 2497

Wes Jean was born over fifty years ago in Toronto. For most of his life, he has used drawing and painting to express himself. He remembers doodling sailboats when he was a young boy and he began to paint with oils in his twenties. Mainly self-taught, through books, TV and trial and error, he has taken a few art courses over the years. He prefers to work with oil paint because it is versatile. He likes to represent life and nature as he sees it. Some recurring themes have been Africa, interesting people and beautiful scenery.

Wes is a building supervisor at Dixon Hall, a social service agency, and describes himself as a part-time artist. He finds it relaxing and hopes other people get pleasure from his art. Although he gives most of his work away, he has sold a few paintings and he takes commissions for portraits and landscapes. In 1991, he completed a portrait for the Canadian Labour Hall of Fame commissioned by the Labourers International Union of North America (LIUNA) and has exhibited in the Working Image exhibition as a part of the Mayworks Festival.

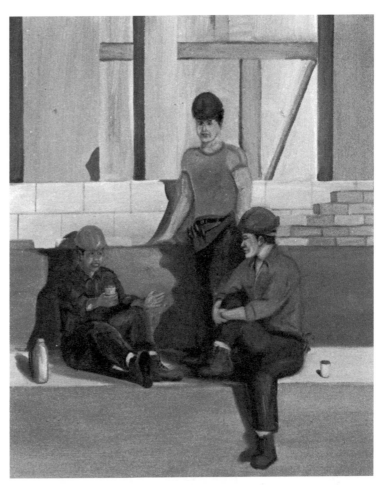

Breaktime, acrylic on canvas, Wes Jean, 1993

Wes Jean at the Working Image exhibition with his work, 1991

On Strike

Paintings by B.A. (Bobbi) Wagner

by Bobbi Wagner

Art is about communicating our vision to others. The union movement is about the power of collective action and the strong helping the weak. Creativity enables an artist to generate something new from old or redundant information.

The *On Strike* (see colour section) series is about my experiences on picket lines in 1989 during the community college strike. It was cold, wet, windy and dangerous. Our debts grew and our resources shrank. We laughed and cried together.

Those days and nights will always be vivid images in my memory. I learned what "brother," "sister" and "in solidarity" really mean. We walked and worked together in the harmony of common purpose and shared hardship. We forged bonds that will last a lifetime.

My intent is to communicate the powerful and positive feelings that I have about my union work.

Bobbi Wagner is President of OPSEU Local 244 and teaches art at Sheridan College. She has painted and created mixed media works dealing with union life, including a banner for her union.

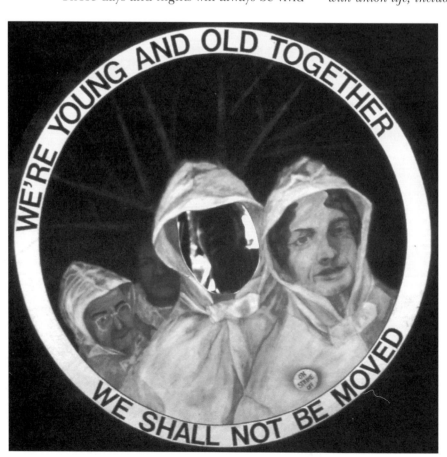

We're Young and Old Together, mixed media on wood, 36" diameter, Bobbi Wagner, 1990

Make Your Mark, intaglio and woodblock, Windsor Print-makers Forum and the CAW, Windsor, 1991

Complax Plastic Moulding Plant, Cobourg, acrylic on wood, 4' x 6', Charlie Stimac, 1988 (From the mural series for the Northumberland & District Labour Council)

Detail: *Fire Fighters' Mural*, Dave Robinson, 1996–97

Amnesty International Stamp by
C. Themptander, Sweden; from The
Mail Art Show by Mike Duquette and
CUPW, 1993

Installation view of the OPSEU mural by Bob Kell, 1989

The Mechanics of Gauging a Trade, cj fleury and members of the Ottawa Buildings and Equipment Facility/ Municipal Workshops (Photo cj fleury)

Installation view of *Paintings of Steel and Strength*, Tony Cooper, Paul Kovanen and members of USWA Local 6571

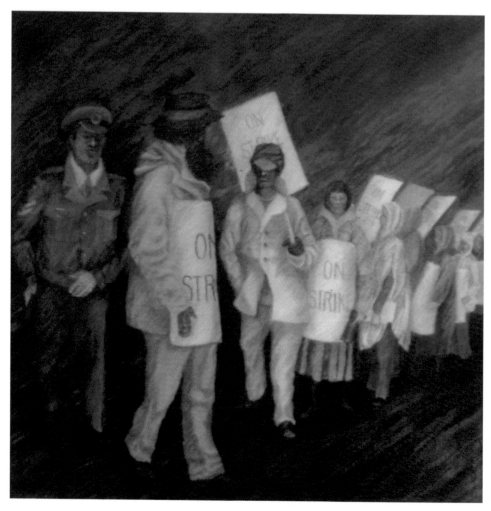

The Wildcard, from the *On Strike* series, acrylic on canvas, Bobbi Wagner, 1990

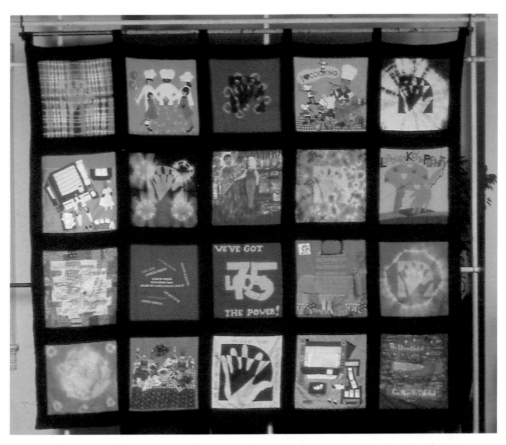

Here 75 banner,
fabric, Winsom,
1996

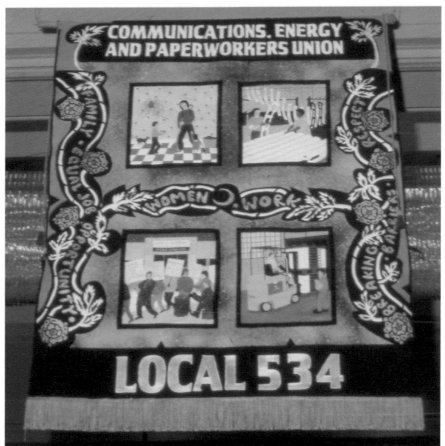

CEP Local 534 banner,
Linda Lapeer and
Dorothy Caldwell,
1995

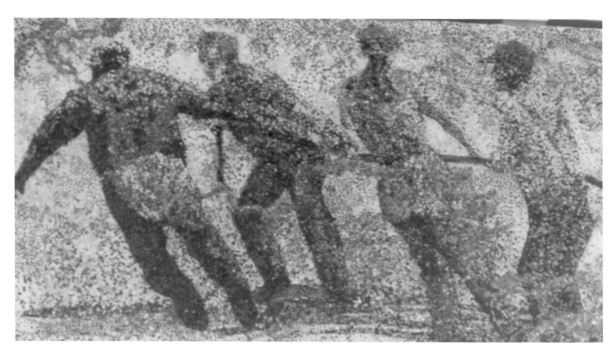

Pulling Together, fabric banner, Laurie Swim with members of Kingston and District Labour Council, donated to the Hotel Dieu Hospital, 1995

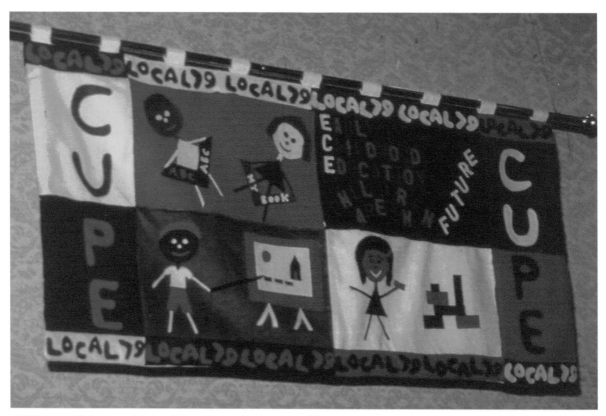

CUPE Local 79 banner, fabric; CUPE 79 members with Judith Tinkle, 1993

Solidarity Banner, a fabric banner made as a collaboration between members of CEP, Mexican and Canadian artists, 1994

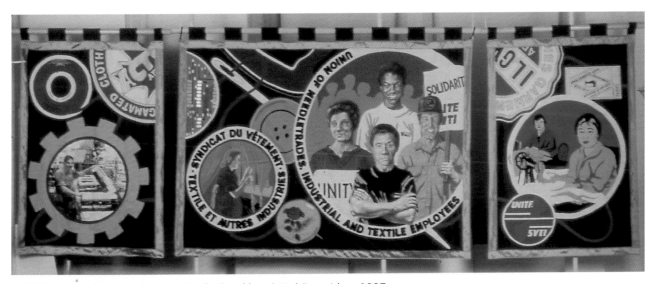

UNITE banner, fabric and paint, Carole Condé and Karl Beveridge, 1997

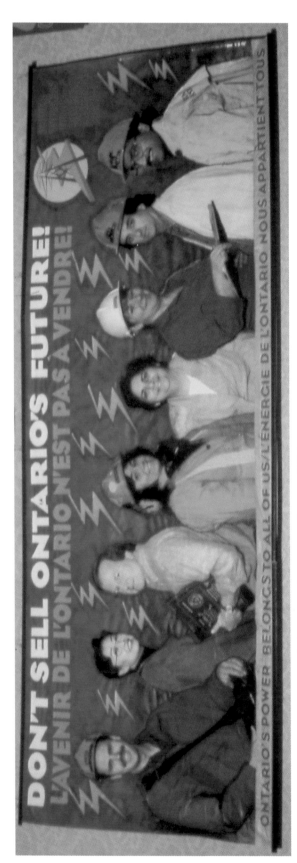

Powerworkers, (CUPE 1000), paint and photo transfer; Joss Maclennan, 1994

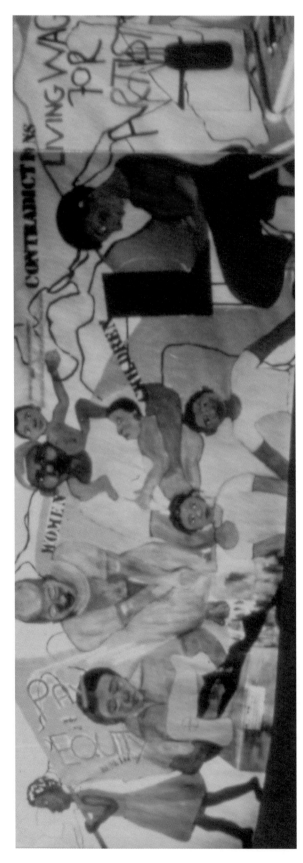

Banner for the OFL, paint on fabric, Buseje Bailey, 1990

The Mail Art Show

An international mail art project by Mike Duquette and CUPW

Mail is about sending and receiving messages, as is art. Postal workers are involved in the process of communication and, in the case of what is known as Mail Art, they become active collaborators with other communicators, namely, artists.

In the early 1990s, artist, union rep and postal worker Mike Duquette sent 2,500 blank, self-addressed cards to artists around the world. He asked them to cover the cards with art work that showed solidarity both with other artists and with postal workers and to send them back. Over 400 exciting and diverse replies were mailed back, cheaply and swiftly. The cards were exhibited as part of the Mayworks Festival in 1989, the year the play *Postscript* was also presented. Many of the mail art cards were made into non-monetary stamps, to once again be circulated throughout the world by postal workers.

Mike has also organized a project for which artists made designs on the theme of Amnesty International (see colour section). These, too, were made into non-monetary stamps and circulated around the world.

Amnesty International Stamp by Jean Noel Laszlo, France

Untitled, acrylic on panel, Mike Duquette, 1989

Partisan Gallery and Union Art Service

Partisan Gallery is a gallery of social criticism which started in 1975 and is still going strong. Partisan activities have included visual arts, music, theatre, agit prop, billboard signs and photomontages about a wide range of topics including child abuse, education and Trudeau's wage and price controls. Partisan was the site of an ongoing writers'

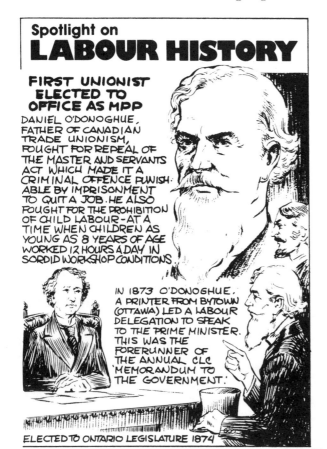

Cartoons from Union Art Service

circle in the 1970s and 1980s, holding the People's Poet Awards and establishing the Broken Monument Press.

Mike Constable has been one of the mainstays of the gallery. For several years, Mike and members of Partisan Gallery made satiric agit-props and floats as centrepieces of the annual Labour Day Parade, organized by the Labour Council of Metro Toronto and York Region. His cartoons have appeared in many union newsletters and events. Almost every day and in various forms, Mike develops new ideas on big banks, the government, life in the margins and progressive issues.

In 1977, Union Art Service was started. It is a subscription service where the work of cartoonists can be purchased which continues today as On Side Cartoons, Union Art Service. Subscribers receive a monthly package of ten cartoons by mail or on-line. On Side Cartoons also publishes discs, both high-resolution floppy and CD-ROM, of the best cartoons. A cartoon history feature, *Stuff They Don't Tell You*, is included.

While Mike has been involved in many projects, his adeptness at using satire as a tool for political and social commentary stands out. His satirical work has appeared on the front pages of major newspapers, on national television and in most of Canada's major periodicals.

Make Your Mark

A print produced by the Windsor Print-makers Forum (WPF) (Michael Califano, Robert Fortin, Barbara Murawski and Tony Mosna) with the CAW

by Tony Mosna

The Windsor Printmakers Forum had the idea of sending a printing plate down the assembly line at one of the Big Three auto plants as a project for the 1991 Windsor Mayworks Festival; we would have the workers draw, write or make marks on a printing plate as it travelled down the line, using the tools they use on the job.

We obtained permission to enter the Ford Essex Engine Plant in Windsor, a plant where engine parts are milled and the V-6 engine is assembled. In preparation for the project, the WPF set up a display in one of the cases in the hallway that leads to the plant cafeteria; the idea was outlined and an etching and the plate that it was taken from were displayed.

A week or so later a group from the WPF arrived at the plant with one Masonite and two copper plates. We began a routine of carrying the plates from one work station to another. The workers knew we were coming and were ready to make marks on the plates using their assembly line tools.

Some wrote their initials, some made a design and others simply took their power tool and scribbled across the plates. One worker drew a piston, one of the engine parts milled at the plant. An operator drove his forklift over one of the copper plates. Another brushed part of the surface of a copper plate with a floor sweeper. It took about an hour to get through the engine plant and collect all the marks.

We decided that although the edition was being printed from the same three plates, we would try to make each print as different as possible without eliminating or adding to the images made at the plant. By printing different colours on each plate and by placing the plates differently on the paper or on top of each other for each print, we made thirty printed variations (see colour section). At a later date, 1,500 copies, based on these variations, were hand-printed for the CAW.

Tony Mosna is an artist and member of the Windsor Printmakers Forum.

Make Your Mark, intaglio and woodblock, 15" x 22", Windsor Printmakers Forum and the CAW, Windsor, 1991

Film, Video and Mixed Media

As the media become more and more monopolized, there is less and less freedom of expression. There are a lot of people who work in the media industry who could relate to everything that has been said (about the arts) and who would like to do a better job but they can't. They're unable to get stuff into the newspaper and that's the reality. A lot of self-censorship is practiced.

Gail Lem,
National Vice-President,
Media Sector, CEP

Artists in this section:

Don Bouzek

Lorraine Segato

Laura Sky

Glen Richards

HERE 75

Joe Chiasson

Re: Connecting

A video by Don Bouzek (Ground Zero Productions) with the Communications and Electrical Workers of Canada

by Don Bouzek

Hamilton, 1988

I am in a jammed Communications Workers of Canada (CWC—now part of CEP) meeting hall to show a rough version of a video about the strike against Bell Canada. Scenes with professional actors who represent the various types of workers in the union—operators, installers, staff—alternate with documentary footage, largely shot by CWC members themselves.

One segment features the Hamilton Local's summer picnic. There are whoops of laughter as people see their kids trying to break a pinata. It has the impact of home movies, but with a political purpose. Afterwards, one woman comes up to talk. I'm a bit worried; unionists are notoriously good at criticism. But no, she just wants to say "This is so different to the way they're showing the strike on TV. Thanks for telling our side of the story."

We all hate the way that most strikes, when reported in the media, become either stories of violent confrontation or painful hardship. This time, we wanted to show the positive energy that is unleashed when working people walk out together. On the picket line, for example, a phone operator gets a chance to share stories with the guy who installs the jacks in your home. Meanwhile, unionists use their creativity to find legal ways of ensuring that all is not "business as usual" for the company. CWC was also working to enhance the social aspects of the experience through events like Local picnics. They saw the strike as an opportunity to help unite a union with a very diverse membership. It was this social process that we wanted to document.

Later, D'Arcy Martin, a union staffer, described the difficult choice to drop some of the most vivid footage because of possible repercussions against the worker involved.

"For (Don) and his colleagues at Ground Zero Productions," D'Arcy wrote, " it was no big deal. It meant taping an actor instead, who would re-tell some of the striker's stories. But the sequence became *about* a strike instead of *from within* a strike. While it may have gained other qualities through good dramatization, the story lost the immediacy and authenticity of the first person voice."*

Vancouver, 1998

I'm in Julius Fisher's converted garage. Because video is now done on desktop computers, Julius can produce his weekly show—*Working TV*—literally in his own backyard. This makes me think about what D'Arcy said about the necessity of continually seeking the most direct method of telling our stories, about the difference between a voice which

Ma Bell as played by Alan Merovitz in *Re: Connecting*

speaks about instead of from within. With my background as a theatre worker, I was very used to robbing people's words to put them in the mouths of actors. *Re: Connecting* was the first time I handed cameras over to union members to show things the way they saw them. The new technologies make this a fairly easy process and it generates a spontaneous energy that is very powerful.

Once people start shooting their own stories, where does it stop? Who controls the material? Video, in particular, is a medium which excludes people from the process of making creative decisions. There is seldom room in the editing suite for all the people involved in the process. One answer is to put a lot of energy into "off-lines," demo versions of the tapes, for feedback showings. Allowing project participants some control, however, demands that the product be tested with the people who generated the stories. In showing "off-lines," I often have to discuss any or all the decisions I made as cultural producer. As D'Arcy points out in his article, a number of the concerns being raised are not just questions of personal aesthetic preference.

There are inevitable tensions between the artistic ego and the need to make something that meets a group's needs. It requires a particular kind of artist to

Djanet Sears portrays a Bell operator in *Re: Connecting*

Bell picket line in Kingston from *Re: Connecting*

engage with it. But, in the end, I've found the result is almost always a richer and more textured product. In this way we create images of a shared truth. "No one can say a true word alone," said Paulo Freire.

We can make the process as collaborative as we like, but there is very little point if no one sees the resulting tape. We made *Re: Connecting* knowing that home VCRs meant that the tape could be seen at Local meetings or in a member's home. I like that idea and am working now to develop a video magazine.

However, sitting here in Julius' garage, another medium stares me in the face. In one

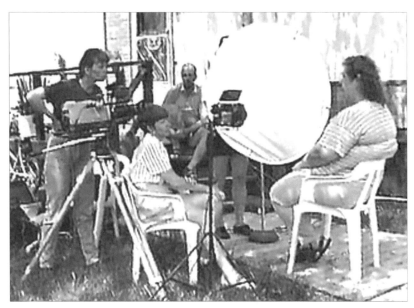

Members of the Northumberland Coalition Against Poverty conduct an interview in a trailer park near Trenton for the tape *Northumberland Voices*, created with the Northumberland and District Labour Council through the Artists in the Workplace program

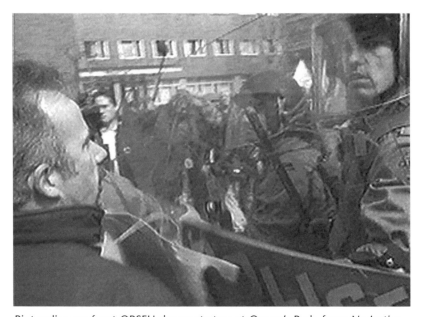

Riot police confront OPSEU demonstrators at Queen's Park, from *No Justice, No Peace!*, a CALM winning video created from footage shot by OPSEU members. Edited and produced by Don Bouzek and Ground Zero Productions.

corner of the studio sits a computer linked to his web site. *Working TV* is in the forefront of delivering video on the internet. The technology is still limited—the pictures are often shaky and the audio is definitely low-fi. It reminds me of my father's descriptions of being a young boy huddled under the bedsheets trying to tune into a radio show on an early crystal set. Now young people are experiencing the same wonder at a new gateway to the world opening in their own rooms.

A lot more media are available today for video activists. I'm waiting for a union to use the opportunity of a strike to mobilize teams of unionists with camcorders so that workers can speak true words to each other. Imagine strikers in B.C. watching within hours on the internet what another local was doing in Newfoundland. Think of the solidarity that this could create.

Don Bouzek has been doing popular theatre and video with organized labour for the past fifteen years and has won numerous Canadian Association of Labour Media (CALM) awards. He now lives in Edmonton and is Community Artist in Residence with the Edmonton and District Labour Council.

*D'Arcy Martin, "Creative Dreams and Labour's Disciplines: When Artists Meet Unions" *Our Times*, Vol. 13, No. 5 (October/November, 1994) pp. 19–22.

Good Medicine

A music video by Lorraine Segato and Laslo Barna, produced by Catherine Macleod for the CAW

by Catherine Macleod

The CAW's 1990 CALM-award-winning Recovery project was an initiative of the union's Substance Abuse Committee and CAW National Representative, the late Jim Kennedy. Because of the sensitive nature of the topic, one that people generally don't like to address in public, the committee wanted a video with broad appeal that could easily be included in the union's education courses. Because time during union educationals is at a premium, the video couldn't be too long or preachy. The committee decided to use the short music video format to get the message out.

Lorraine Segato met with the Substance Abuse Committee, members of Local 27 in London and with workers at the Ford Plant in Oakville. After listening to their ideas and personal stories she went to work on lyrics with fellow musician Dave Gray and with Laszlo Barna on a script. The song "Good Medicine" was released to radio stations as a single and made the charts across the country. The video told the story of one CAW member's successful battle with booze and cocaine.

Professional actors were used to portray the main characters. Workplace scenes were shot at Boeing/de Havilland and a number of Local 252 members played the extras during the shooting. Jerry Dias, the local's president at the time, made a cameo appearance as a bartender. For the final scene, the camera crew and actors joined a mass demonstration in support of injured workers at Queen's park in Toronto and were thus able to include shots of thousands of workers and their families in the final cut.

Dias said the fact that the *Good Medicine* video was shot on site at de Havilland and at Queen's Park was a real boost for the substance abuse program in his local: "It was the talk of the plant for weeks." The song was broadcast regularly on MuchMusic Television and members made sure it was also broadcast on their community cable television channels and in local schools and community agencies.

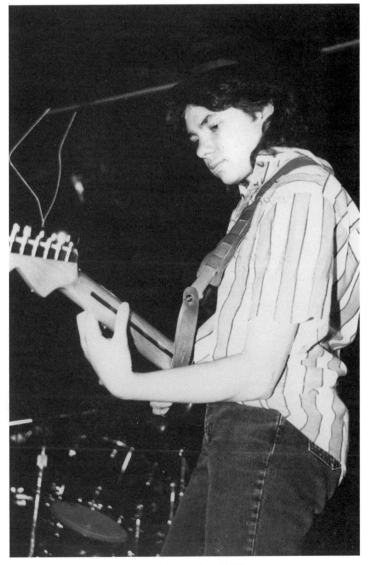

Musician Lorraine Segato at Mayworks, 1987

Sky Works

Films by Laura Sky with various unions

Laura Sky began her career as independent film director and producer after eight years at the National Film Board.

Yes, We Can! flier, Sky Works

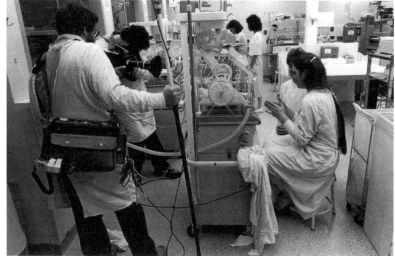

Laura Sky's team (Photo Vince Pietropaolo)

In 1986 she formed Sky Works, a non-profit, educational, documentary film production company. Sky Works films, its brochure says, are "designed to encourage specific audiences to see the value of their own experience and to take action on their own behalf." Some of the films are about work and unions, others are about contemporary social issues.

- *Moving Mountains,* produced in 1981 with USWA, shows the women of Elkford, British Columbia, working alongside men in an open pit mine. The women are also shown as members of blasting crews and as drivers of gigantic bungalow-sized bulldozers and loaders. The women were hired by the company only after USWA initiated human rights complaint procedures.
- *Good Morning Monday Morning* is a 1982 film about "work life and the women who live it" in white- and pink-collar ghettos.
- *To Hurt and to Heal* is a film package on pediatric ethical issues faced by patients, parents, nurses, doctors, social workers and the public. These include the impact of new technologies and techniques on the lives of children. Many children now survive illness or trauma that previously would have been fatal. In the film, participants describe actual incidents.
- *Yes, We Can!* is a film sponsored by CUPE in 1984 portraying CUPE women across the country.
- *Crying for Happiness,* 1991, is a film package about ethical issues in psychiatry, including consensual process, patient and staff autonomy and accountability. The impact of poverty and isolation on mental health and the medicalization of these issues by health care professionals are also explored. Many of the issues it raises have influenced new legislation and health care policy.

De-Industrial Strength Soap: A Continuing Labour Story

A video by Glen Richards with the Labour Council of Metropolitan Toronto and York Region

by Glen Richards

Students who completed my video production course at Humber College (through the Labour Studies program) wanted to continue making video. The group of labour activists decided to examine the issue of plant closures and to try and complete a documentary video on de-industrialization with the Labour Council of Metropolitan Toronto and York Region.

After the group had interviewed workers affected by plant closures as well as their families and several union staff, the original idea of a documentary took an interesting turn. I had been impressed by the work of the Brazilian metal workers' union who ran one of the most popular soap operas on Brazilian television. The group got creative and decided to produce our own soap opera. The result was a thirty-minute video titled *De-Industrial Strength Soap: A Continuing Labour Story.*

Out of the interviews, the group developed a plotline and characters and wrote three episodes, each to be shot by its own crew. The script had been circulated to a number of union members for comments and feedback. As is often the case, most of the readers said "Hey great" and then voiced their criticisms after the video was finished. Production took place on weekends and the actors were non-professional labour activists or their friends. I had a cameo role

as a capitalist boss. More than thirty people were involved at one time or another. Two episodes were made as only two of the volunteer crews turned up.

The video was premiered on the big screen at Mayworks in 1989 and again at the Images Festival in Toronto the same year. The group continued to work together, developing an electronic newsletter on labour issues. Although the continuation of *De-industrial Soap* was not possible, I still think there's a working class soap to be made that could run on national TV.

Glen Richards is a video artist who has completed many works for the union movement. Putting It Together/Differently, *a recent video for the CAW, introduces union members to the history of photo montage and political art.*

Scene from *De-Industrialized Soap*, Glen Richards, 1989

Scene from *De-Industrialized Soap*, Glen Richards, 1989

Unionists as Cultural Workers

Hotel Employees Restaurant Employees (HERE) Local 75 Culture Fund and labour arts activities

HERE Local 75 recognizes that culture is a part of Toronto's social fabric. Community arts, music, theatre, dance and literature are ways to become involved, not only for new arrivals to the city but for those who want to celebrate diversity and community spirit. As well, there are budding actors, singers and painters within the culturally diverse membership of HERE who provide hospitality service to the public. They produce art both as individuals and as union members.

The Local has produced several banners (one with artist Winsom) and an audio tape of original and cover songs (with Scott McLaughlin-Marrato, Anne Healy, Kevin Barrett and members of HERE 75). A music video of Mclaughlin-Marrato's song "We're the Ones" was produced by Glen Richards and HERE 75 member Anne Healy. A band of HERE 75 members performs regularly at union events.

While several projects were jointly funded by HERE 75 and the OAC Artist in the Workplace program, members have also independently made paintings, banners and a video project with the Mayworks Festival. HERE 75 has recently developed its own Culture Fund to provide seed money for cultural activities by Local 75 members/artists, as well as for community arts, labour arts, heritage projects and the promotion of cultural tourism. Many Local 75 members work in tourism and they know that cultural tourism need not involve stereotypical presentations of the city's diversity. Instead, tourist activities can celebrate and involve all of the city's workers and communities. HERE 75 believes that an inclusive and redeveloped tourist trade would be richer in content. It would not only pay off financially for Toronto but would truly reflect the spirit of the city and its workers.

HERE 75 President Paul Clifford in front of a banner made by members

Music by the union member band at a HERE 75 event

Joe Chiasson

Master Prop and Banner Maker

Joe Chiasson retired from CUPE in 1984 but continues to fight the labour fight with fabric, paint, stitches, hammers and nails. His house is the backdrop for multi-coloured placards and signs. Over the years Joe has contributed to labour parades and meetings with his unique banners, props and floats made with heartfelt enthusiasm. When Joe's wife Vi asked him when he might quit all of this labour activity, his answer was, "Not yet … As long as I can keep going, I'll do it."

Joe's work was a major feature in the struggles against free trade and the policies of Brian Mulroney. His NAFTA Graveyard appeared outside of the Toronto Convention Centre during the huge protests against the federal Tories and at the Ottawa Day of Protest in the early 1990s. Joe has also created several floats for the Labour Council of Metro Toronto and York Region for the annual Labour Day parade.

As Joe says, "We in the labour movement are very reluctant to publicize our activities. How many times at conventions and other meetings have we listened to inspiring speeches that finish with standing ovations and not a word goes into print to let the people outside know that it took place. We lose a lot of public relations through our shyness."

Currently Joe has several signs in front of his house, including two which say, "Most Canadians outside of Quebec want to negotiate the Quebec problems" and "Canada is worth fighting for." Joe has also made banners and placards about the problems in Canadian fisheries and on the impact of poverty. Joe says that he wishes he was twenty again as there is "so much to do."

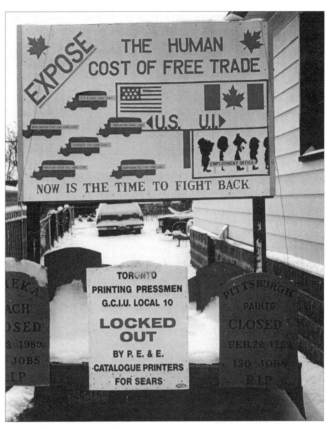

Free Trade Float, Joe Chiasson

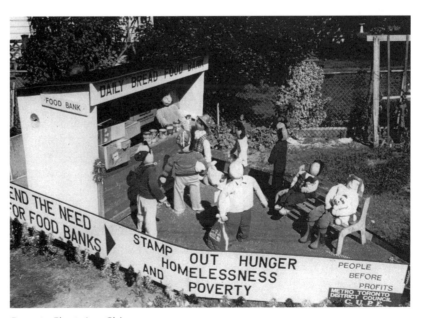

Poverty Float, Joe Chiasson

Photography

We try and involve people. A lot of shop floor people in my plant aren't interested in anything other than the contract and they don't want to go to union meetings and stuff. So you ask them if they play an instrument. We introduce them to a story circle or a song circle where they have an opportunity to tell a story or recite some poetry. You start to explore their interests, be it photography, writing, any of that sort of thing. We have to get our message out and the way I find to do this is through the arts.

Tom Veitch,
President, Peterborough District Labour Council

Artists in this section:

First Nations Photographers

Jim Miller

Pam Harris

James Williams

Vincenzo Pietropaolo

Gayle Hurmuses

James Masters and Heidi Bergstrom

Lisa Sakulensky

David Smiley

David Hartman

David Zapparoli

Karl Beveridge and Carole Condé

Portraits of Ironworkers

An exhibition of photography curated by Scott Marsden and Nancy Naves

"Ironwork is an extension of the traditions of our ancestors. Mohawk men have been ironworkers for over 130 years," Tom Hill explains in his book, *Skywalkers, A History of Indian Ironworkers*. "Ironworkers perform a very ancient skill—they build structures, not unlike their ancestors who built 200-foot-long houses ... Building is part of our tribal identity."*

The book accompanies an exhibit of twenty black and white photographic images examining the working lives of First Nations ironworkers, curated by Scott Marsden with Nancy Naves of the Native Indian/Inuit Photographers Association in Hamilton. First Nations ironworkers were depicted building and constructing larger-than-life structures as well as performing minutely detailed work with hand tools on steel girders.

Ironworker Stan Hill, Richard Hill, 1991

Artists participating in the exhibit included Martin Bomberry, Denis Garlow, Richard Hill and Joel Johnson. The exhibit was shown at the OPSEU headquarters in 1994, at the twentieth anniversary celebrations of the CLC in 1995 and at the 1998 George Brown College Labour Fair.

Iron Worker, Martin Bomberry, 1991

*Tom Hill, *Skywalkers, A History of the Indian Ironworkers* (Brantford: Woodlands Cultural Educational Centre, 1987) p. 10.

Making Time

A photographic installation by Jim Miller with the Hamilton and District Labour Council and CUPE Locals 778, 794 and 5

by Jim Miller

In the 1870s, workers in Hamilton were pioneers in the movement to win a nine-hour work day. After the Second World War, Hamilton's trade unionists led the way in establishing the forty-hour work week that later became the national standard.

The installation project examines how the pressures of time on the job affect workers today. My research led me to public service workplaces where downsizing and privatization were exacting an extreme toll—not only on the workers but on the public service they provided. I focused on two sites, a hospital and the Hamilton Blue Box recycling program. The work was based on interviews with workers about how time affected their work and incorporated documentary images, constructed props and text of stories.

A worker who participated in the project gives a sense of the installation's dramatic power and urgency:

One of the main changes within the last couple of years is the number of infections that have been coming into the hospital. We've come to a point now where we have eight different strands of one certain respiratory infection called MRSA. Some of them are life-threatening to the patients, so it's life-threatening to us. It spreads all over, so every day we have to go and do these rooms. It's a rush to get the infection extinguished from the room and make sure that you get back to the O.R. on time. With cutbacks it's really gotten bad. They are not hiring new people. It just burns you out.

Trevor Slaghammer,
Housekeeping, Hamilton General Hospital, CUPE Local 5

Making Time was exhibited at the OWAHC and the Mayworks Festival in Toronto in 1997.

Jim Miller is an artist who has worked in various media. His work has been exhibited across Canada and internationally.

Installation of *Hospital Work* from Making Time, mixed media, Jim Miller, 1997 (See also p. 15) (Photo James Williams)

At Home and in the Workplace

A photography workshop conducted by Pamela Harris with OPSEU Locals 588 and 599

by Pam Harris

I met once a week for nine weeks in 1988 at a small rental darkroom in Toronto's east end for a photographic workshop with OPSEU members working at Centennial College. The workshop had been spearheaded by Keith Clarke, an OPSEU member, and was supported by Locals 558 and 559.

The seven women and five men were largely strangers at the start of the workshop, since they had come from a variety of jobs and more than one Centennial campus. They worked together, however, with camaraderie. Participants with previous photographic experience helped those for whom the process was totally new. They all survived the less-than-ideal darkroom with a good sense of humor. At the beginning of the workshop, the group decided that they were looking for hands-on experience in developing, printing and editing their work. At the end of the workshop, they all had new knowledge about the art and practice of photography. Some felt ready to set up darkrooms at home while others intended to push for access to the Centennial College darkroom.

Their work showed the variety of the participants' lives and experiences. A selection of their photographs was published in the OPSEU magazine, *Voices*. Participant John Parkes comments, "It was interesting to come into work with a camera, to begin to look at work in a different way." Working with the other participants in such a mutual undertaking, he says, gave him "a whole new perspective on people."*

The perspective was shared by all the members of this friendly, hardy, group and for each of them it had been a rewarding and enjoyable nine weeks.

Pam Harris is a photographer who has exhibited across Canada and internationally. Her book Faces of Feminism *was published by Second Story Press in 1992.*

Mable Alfred, Data Processing Department, Centennial College, Alberta Khan, workshop participant, 1989

After Work: Lynn Clarke at Home, Keith Clarke, workshop participant, 1989

*"Focus on Family and Friends," *Voices* (June, 1989), p. 16.

Steeltown

Photographic installations by James Williams

by James Williams

Steel has played a primary role in my life. Members of my family have been employed by one of Hamilton's largest steel producers for more than half a century. For much of the past century, the steel industry has been the single largest employer in the city.

Issues of industry, labour and working class representation are the major focuses of my work. *Steeltown* is an ongoing examination and documentation of steel-making and related industries throughout the world. Recently, I have worked in Mexico and Germany.

I start by introducing myself and talking about the project in the workers' lunchroom before the shift starts or during coffee breaks. I explain how I worked at a factory for over twelve years and that the portraits are going to be part of a larger photographic installation. They will become windows into the factories and illustrate the human element of the industry.

After the lunchroom presentation, I take the photographs, always remembering that the workers are on a time clock. Later, I return to the plants and give prints to all the people I have photographed. The portraits are then mounted to form a large photo mural of the workplace.

I want this work to provide a positive reinforcement for working class people in a society that treats heavy industry and hard labour as an embarrassment. The installations portray a struggle for survival at a time of changing modes of production. Using the various perspectives of the workers themselves, the photographs show that when steel companies close down or pull out, the survival of entire towns can hang in the balance. For me, as well as many of the workers affected, it is disconcerting to see so much power in so few hands.

James Williams is a photographer who has exhibited his work across Canada and internationally.

Steeltown, the Mexican Chapter, mural #16, photo-montage detail, James Williams, 1996–97

Steeltown, Southern Ontario, mural #8 (second version), photo-montage, James Williams, 1994–95

See Ourselves —See for Ourselves

A photography workshop conducted by Vincenzo Pietropaolo with CUPE Local 79

by Vince Pietropaolo

The project *See Ourselves—See for Ourselves* was a series of discussions, on-site workshops and darkroom sessions I held with members of CUPE Local 79, (municipal workers in the City of Toronto). I'm a former member of the local. We started by gathering in the union hall but soon participants took their cameras to work and began to document their workplaces. They processed the film in my darkroom and learned to make their own prints with my assistance.

Members of CUPE 79 in Vince Pietropaolo's darkroom

Photograph by Bushra Jinaid, member CUPE 79

Algoma Steel, Sault Ste. Marie, Vince Pietropaolo, 1996

The workshops dealt with issues of visual language, propaganda and identity as represented in photographs. The participants analyzed newspaper photos (chosen at random), historical images and magazine advertisements. We talked about the representation of workers and the workplace.

More than forty members responded to the flyers sent out by the union. It was decided that all of them had to be accommodated. The project had to be inclusive as it was not going to be another photo contest with pretty sunsets, but a sharing of ways of expressing, through photography, each member's experience of the workplace. For most, it was the first time that they stopped to think about how they were going to represent their workplace and how they wanted others to see it.

The exhibition was the first time that the members had seen their work hanging on a public gallery wall and reproduced in a publication. The project was repeated twice more and the exhibit became an annual event at the Mayworks Festival.

Vince Pietropaolo is a photographer who has worked extensively with the trade union movement. One of the two books of his photographs to appear in the spring of 1999 documents the Ontario Days of Action, and will be published by Between the Lines Press.

Extended Family

A documentary project by Gayle Hurmuses with the CAW Local 303

by Gayle Hurmuses

Around Thanksgiving of 1989, General Motors announced that they would be closing the van plant in Scarborough, Ontario. On May 6, 1993, production ceased and the process of dismantling began.

The community within the plant was a network which crossed boundaries of race, culture, gender and age. The factory was loud, grimy and chaotic yet it was thoroughly humanized by the spirit of its inhabitants. From the paint shop garden to plant gate collections, the plant was a tightly knit community.

To ensure that the passage of this community would not go unmarked, I was asked to document the workforce as part of a union and government-sponsored heritage project. It became an enormously personal document as I, too, was a longtime employee at the van plant.

The project is my tribute to that community, to my "extended family." The project includes photographs that were shot on earlier occasions at parties, parades and events as well as new photographs I took of the plant. The goal was to give a human face to the jobs that were lost and to make apparent the intangible losses that cannot figure in economists' charts.

I had in mind several other themes. One of these was the work which drew everyone together and provided a common purpose. Another was the community which provided respite from the drudgery. It also included the way in which the work environment was humanized and made into a habitat with its own crude beauty. Underlying all of these, of course, was the very subjective theme of my own complex relationship to both the van plant and the people who worked there.

Tony Lyons and Inderbhatia, from *Extended Family,* Gayle Hurmuses, 1993

The work was exhibited at the Scarborough City Hall, in the community in which the van plant had been located. Images from the project have appeared in many magazines and newspapers accompanying articles about the plant closure. A CD-ROM version of the project combining the photographs, video interviews and a series of animated sequences related to the life of the community has been produced. The project is a unique historical document, an inside view of a way of living and working that is quickly disappearing.

Gayle Hurmuses is a photographer working in Toronto. Her project Extended Family *has been widely exhibited and phtographs from it published in several national publications.*

Barry Mitchell in the Wintergarden, from *Extended Family,* Gayle Hurmuses, 1993

The Labour Art Project: Catching the daily life of workers in Grey and Bruce Counties

A documentary project by James Masters (photography) and Heidi Bergstrom (concept and curator) with the Grey Bruce Labour Council

by James Masters and Heidi Bergstrom

We wanted our photographs to capture, as much as is possible in twenty-four hours, the daily life of working people in Grey and Bruce Counties in Ontario. The day, however, stretched out to two, June 10–12, 1997, and the photographs are not of staged scenes but of spontaneous moments, fleetingly observed. We, as photographers, aimed to be unobtrusive. We had a route to travel and few expectations other than a timetable. We soon found that many places had to be missed because of time. James Masters' experience working at the Owen Sound *Sun Times* as a photojournalist, however, and the helpfulness and planning of the workers who took us through the sites and introduced us to subjects, made things easier at the sites we did visit.

One of our days started at 5 a.m. with no breakfast as no restaurants were open on the way to the ferry boat *Chi-Cheemaun* in

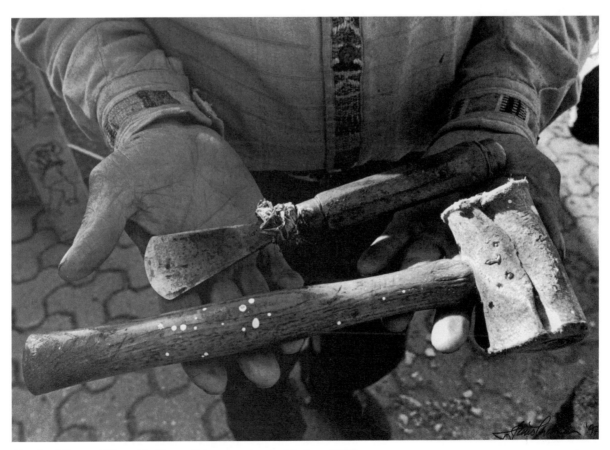

Hands of Carver, Wilmer Nadjiwon, Tobermory, James Masters, 1997

Waiting for grain to be milled, Harold Woodhouse, Walters Falls Feed Mill,
James Masters, 1997

Tobermory on our way to Manitoulin Island. We finished the day at about 11:15 p.m. with some interesting stories and a welcome beer with the Brothers at the International Woodworkers of America (IWA) Local 500 in Hanover. We covered more than 900 kilometres, James took more than 1,100 photographs and Heidi recorded four hours of conversations with workers.

James was able to show his feelings in the photographs without the usual journalistic constraints during the project. The work became the sum of his experiences as a person, an artist and a labourer. Heidi came away more in awe than ever of the unacknowledged moments of daily life. It often seems that whole lives can pass by unnoticed. But for a moment, at least, we had captured a small part of some of them.

The collection of one hundred black and white photographs was exhibited at the Durham Art Gallery in 1997, and at the CAW Family Education Centre, Port Elgin, and the OWAHC in 1998.

Heidi Bergstrom is a visual artist living on a farm outside Durham. She was recently the Curator/Director of the Durham Regional Art Gallery.

James Masters works as a professional photojournalist at the Sun Times, *Owen Sound. His photographs have been published and exhibited across Canada. He is a member of the CEP.*

Garment Worker Photographs

Documentary photographs by Lisa Sakulensky with the International Ladies Garment Workers Union (ILGWU) (now UNITE)

by Lisa Sakulensky

The subject of garment workers has always been important to me; my mother, a single mother of two, worked in the industry from the time she immigrated to Canada in 1957 to the time she retired in 1986. As a child, I would occasionally accompany her to work and sit and play at an empty machine. From that vantage point I could quietly observe the work of the sewers, pressers, cutters and bundlers.

I felt privileged, almost twenty years later, to be able to document the demanding worklife of my mothers' peers. I couldn't know that within ten years many of these shops would close, changing the Spadina Avenue garment industry forever. My photographs pay homage to the dedication and hard work of the people that made the garment industry part of their day-to-day lives.

Lisa Sakulensky is a photographer working in Toronto. Her work has been exhibited at the Mayworks Festival.

Sewing Machine Operator, Gordon Dress, Toronto, Lisa Sakulensky, 1987

Presser, Jac Ann Formals, Toronto, Lisa Sakulensky, 1985

Documenting the Workplace

Photography by David Smiley and David Hartman

David Smiley and David Hartman document unions and trade union struggles and have worked, too, with various communities. But their approaches are very different. Hartman is like a photojournalist documenting the cause. Smiley photographs people he knows or gets to know while working. Hartman records the larger movement while Smiley looks at specific moments within it. Much of their work is directly commissioned by unions.

Both photographers have also worked on their own projects, covering struggles and events such as the Days of Action in Ontario and union conventions and strikes. Smiley has worked with Eric Mills who writes about poverty issues, and with workers in the Parkdale community on issues of health and safety. Both projects were exhibited at Mayworks. Hartman, too, has shown his work at Mayworks.

Smiley conducted a photo workshop with the United Brotherhood of Carpenters and Joiners of America (UBCJA) and Hartman did extensive documentary workshops with OPSEU members across Ontario, both as part of the Artist in the Workplace program. The two photographers have helped create an invaluable archive of images of work and struggle in Ontario.

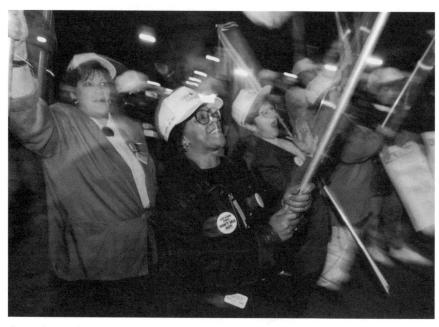

Nick the Cycling Postperson Delivers, from *Island Stories*, David Smiley, 1997

From *Days of Action*, David Hartman, 1997

Regent Park

A documentary project by David Zapparoli, member CUPE Local 2497 (Dixon Hall).

Life feeds art and art feeds life—this has been David Zapparoli's experience over the last ten years.

Many artists start by drawing on their personal experiences and history. Since 1988, David Zapparoli has been photographing the Regent Park public housing project in Toronto. When he lived there as an adolescent in the 1970s and 1980s, he was aware of the stigma that affected—perhaps unconsciously—many of those who lived there. After moving away from the community in 1984, he became more aware of the profound effect this had, not only on himself, but on the thousands of residents that call it their home. His objective has been to increase awareness of the way of life of the people that live there, of the ordinariness of a community whose image has been distorted by a media that is hungry for sensationalism.

Much of David's documentary photography has been inspired by his work as a program coordinator with children and youth in the community. In turn, his photographic work has allowed him to share his creative experience and inspire other community members. The community has contributed to this work by providing additional materials in the form of personal writings and historical records.

Since 1992, David has been working on a predominantly autobiographical study of how social and ancestral elements combine to produce an individual. Over the years, the meaning of the term *Canadian* has been expanded and revised by successive waves of immigrants. David's work is intended to provoke and encourage discussion of these changes. At the same time, he hopes, the experimental use of photography and the combination of various documentary elements will produce a challenging, yet accessible, aesthetic statement.

David Zapparoli is a community worker and artist. He works at Dixon Hall and is President of CUPE Local 2497. His work has been exhibited across Canada.

Charlie and Melissa, from *Regent Park*, silver print, 11" x 14", David Zapparoli, 1991

Block-o-rama, from *Regent Park*, silver print, 11" x 14", David Zapparoli, 1990

Pulp Fiction

A photographic project by Carole Condé and Karl Beveridge with CEP

Espanola is one of the older mill towns in Ontario, a few miles west of Sudbury. Since the Second World War, it has been at the centre of many environmental debates. The most famous is a case in which local fishermen sought an injunction against the mill in 1947 for polluting the Spanish River. After intensive lobbying by the owners and the union at the mill, the then Premier of Ontario pushed through special legislation virtually exempting the mill from environmental liability.

Looking back, pulp and paper workers say it was the price of doing business. In those days they didn't realize the environmental costs of unregulated resource use. Many credit their children with making them environmentally aware. But they still have little patience with "people from the Danforth wearing sandals," a reference to environmentalists from Toronto. For workers, the issue is one of local community control to ensure the sustainable use of the forests and rivers and to protect their future livelihood.

Carole Condé and Karl Beveridge visited and talked with members of several CEP pulp and paper locals in Northern Ontario from 1992 to 1993. They documented mills and forest sites and researched the industry, the union and its history. They showed the union members storyboards with drawings for a series of staged photographs showing both the history of the 1947 injunction and the issues that concern workers today. After much discussion with the members, Carole and Karl finalized the images, got together the actors and sets and photographed a series of thirteen images they call *Pulp Fiction*.

The images were first displayed in the local library. The union local now uses them to talk to school kids about issues of work and the environment. The work has been presented at various CEP conferences and meetings and has been used as part of its educational seminars.

"DO FISH COME BEFORE PEOPLE? WHAT ABOUT THE RIGHTS OF PEOPLE HERE TO MAKE A LIVING?" JAMES LEITCH, PAPERMAKERS UNION

1949, from the series *Pulp Fiction*, Cibachrome print, 24" x 30", Carole Condé and Karl Beveridge, 1993

Index of Artists